Garment Graphics

ROCKPORT

© 2009 by Rockport Publishers, Inc.
This edition published 2011

First published in the United States of America by
Rockport Publishers, a member of
Quayside Publishing Group
100 Cummings Center
Suite 406-L
Beverly, Massachusetts 01915-6101
Telephone: (978) 282-9590
Fax: (978) 283-2742
www.rockpub.com

Library of Congress Cataloging-in-Publication data available

ISBN-13: 978-1-59253-704-4
ISBN-10: 1-59253-704-9

10 9 8 7 6 5 4 3 2 1

Design: Jeffrey Everett of El Jefe Design
Layout: Megan Jones Design

Printed in China

JEFFREY EVERETT
EL JEFE DESIGN
THE WHO, WHAT, WEAR

BEVERLY MASSACHUSETTS

ROCKPORT
PUBLISHERS

1000

Garment Graphics

A Comprehensive Collection of Wearable Designs

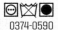

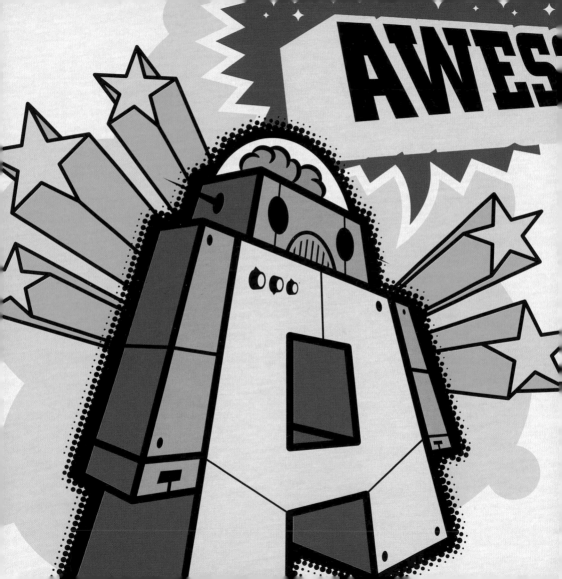

 arments, and garment graphics in particular, are ubiquitous. On any given street you may see dozens—if not hundreds—of people wearing different patterns, images, and phrases on shirts, purses, shoes, coats, dresses, and much more. Most of the time these graphics tend to be bland and stale; landscape noise that fades into the mind's background as you tend to your thoughts. Uninteresting doodles, generic logos, and mindless fluff are put together haphazardly to appeal to the lowest common amoeba; filler to make a blank $1 T-shirt worth $3.

On occasion, though, there will be an image that makes you do a double take. The graphic will snap you out of your thoughts and make you smile, smirk, think, or just feel bewildered. The sensibility is proudly distinct, possibly using inside jokes, sarcasm, fringe culture iconography, painfully rendered type, or satire of a beloved idol. These graphics stand in stark contrast to the overwhelming homogenization and conservatism that characterize committee-created corporate products, which are cool only if you can poke fun at them.

This book is a unique collection of garments that bring a sparkle to the jaded eyes of the passerby. From around the world, the designers whose work is featured in this book have elevated garment graphics from a piece of cloth to be forgotten in a closet, to proud displays of personality and wit to be showcased like a heart on your sleeve.

JEFFREY EVERETT
EL JEFE DESIGN

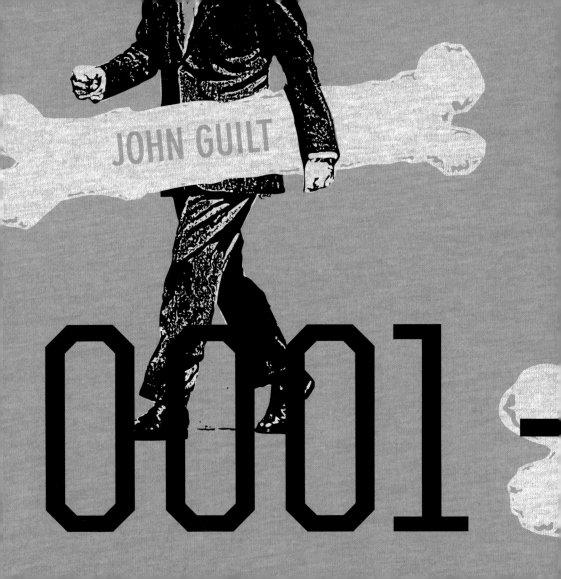

Figures & Faces

JOHN GUILT

0183

0002 Black Van Industries

0003 Black Van Industries

0004 Black Van Industries

0005 Black Van Industries

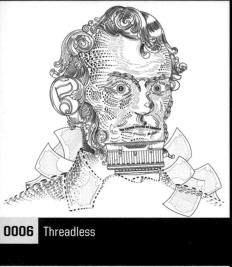

0006 Threadless

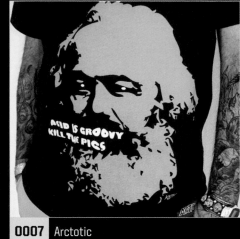

0007 Arctotic

0008 Ames Bros

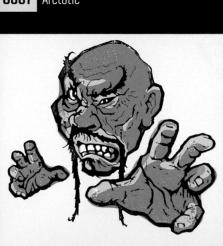

0009 Ames Bros

0010 Arctotic

0011 Hybrid Design

0012 Ames Bros

0013 Ames Bros

0014 Hybrid Design

0015 Hybrid Design

0016 Hybrid Design

0017 Hybrid Design

काली / Mother Goddess

0019 Threadless

0020 Threadless

0021 Di Depux

0022 Hive Creative

0023 Ames Bros

0024 Ames Bros

0025 Hybrid Design

0026 Hybrid Design

0027 REBEL8

0028 Ames Bros

0029 Ames Bros

0030 Ames Bros

0031 Nodivision Design Syndicate

0032 Ames Bros

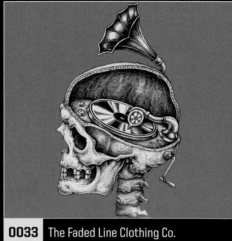

0033 The Faded Line Clothing Co.

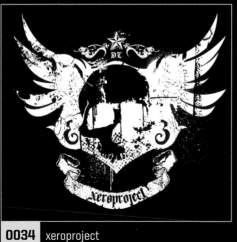

0034 xeroproject

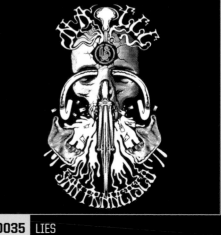

0035 LIES

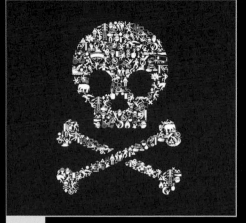

0036 Threadless

0037 Threadless

0038 Methane Studios, Inc.

0039 Methane Studios, Inc.

0040 Ames Bros

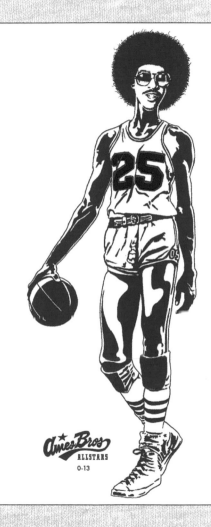

0041 Ames Bros

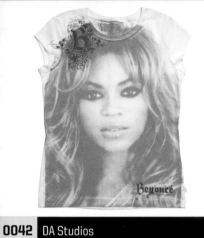

0042 DA Studios

0043 DA Studios

0044 DA Studios

0045 DA Studios

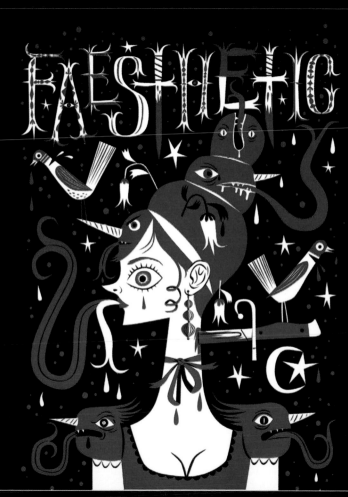

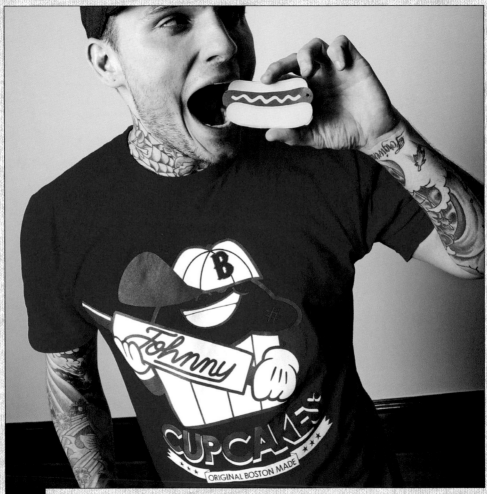

0047 Johnny Cupcakes

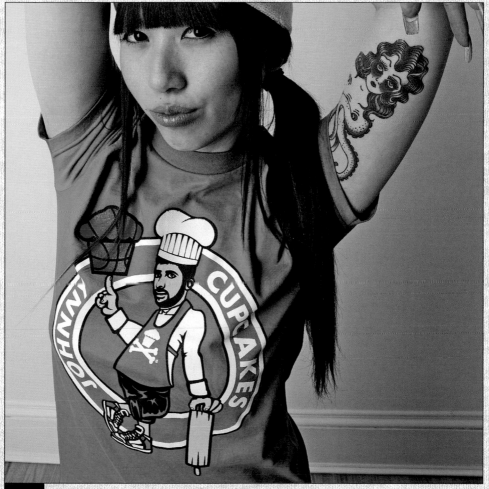

0048 Johnny Cupcakes

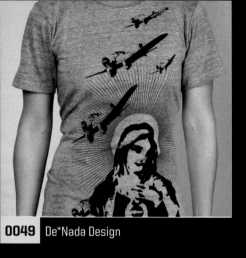

0049 De*Nada Design

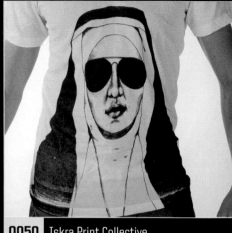

0050 Iskra Print Collective

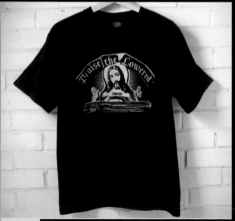

0051 Black Van Industries

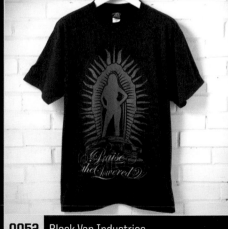

0052 Black Van Industries

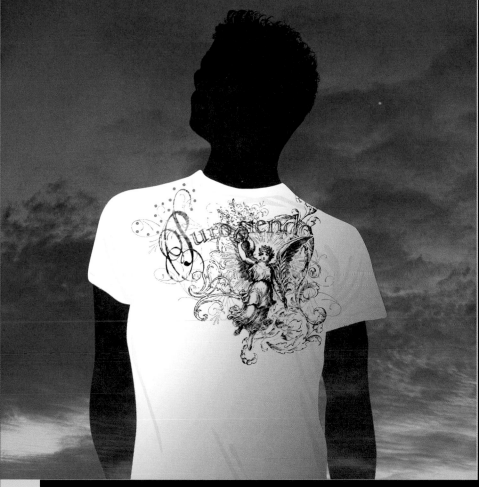

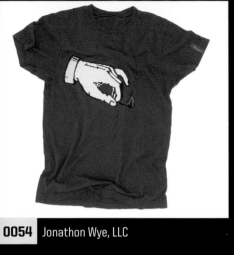

0054 Jonathon Wye, LLC

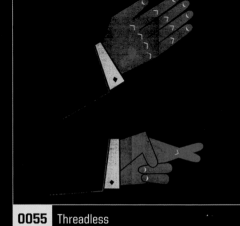

0055 Threadless

0056 Good Night TV

0057 Threadless

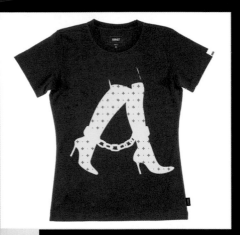

0058 Addict LTD

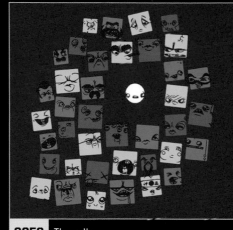

0059 Threadless

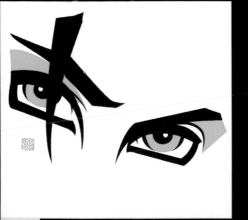

0060 Ames Bros

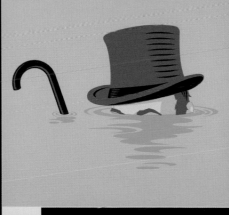

0061 Threadless

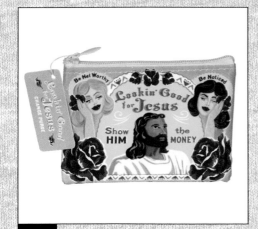

0062 Blue Q

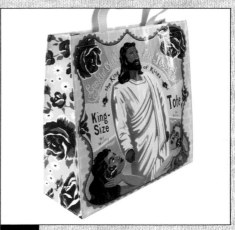

0063 Blue Q

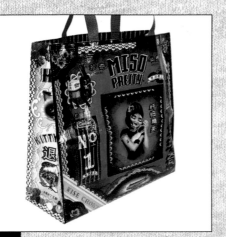

0064 Blue Q

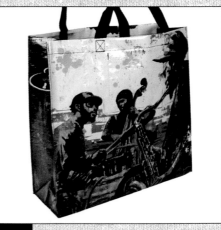

0065 Blue Q

0066 Blue Q

0067 Blue Q

0068 Blue Q

0069 Blue Q

0070 The Faded Line Clothing Co.

0071 Sukseed

0072 Threadless

0073 Alphabet Arm Design

0074 Methane Studios, Inc.

0075 Alphabet Arm Design

0076 Ames Bros

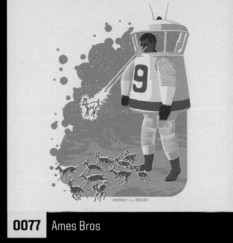

0077 Ames Bros

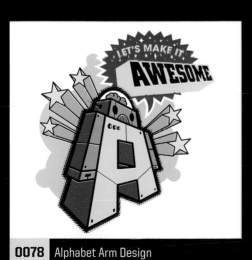

0078 Alphabet Arm Design

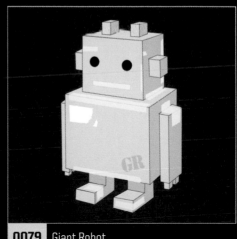

0079 Giant Robot

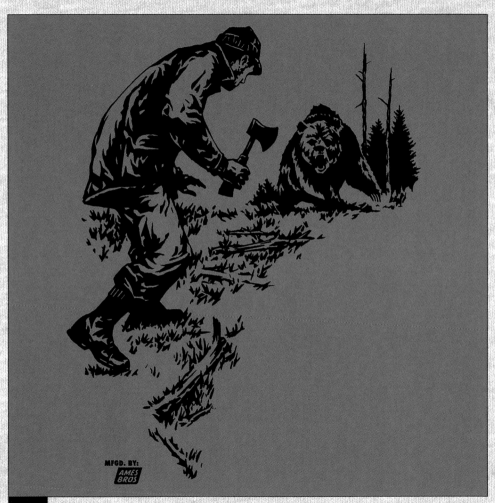

0080 Ames Bros

0081 Ames Bros

0082 Sheriff Peanut

0083 El Jefe Design

0084 Hybrid Design

0085 Squidfire

0086 Sheriff Peanut

0087 Threadless

MFGD. BY:
AMES BROS

0088 Ames Bros

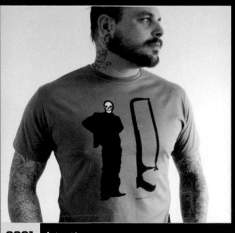

0091 Artcotic

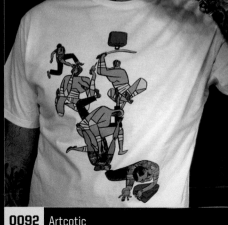

0092 Artcotic

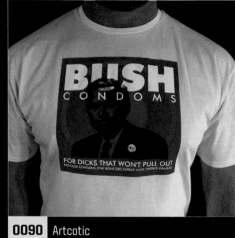

0090 Artcotic

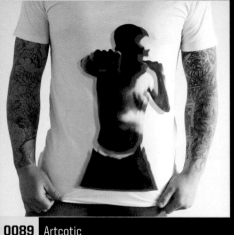

0089 Artcotic

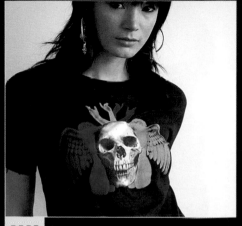

0093 Artcotic

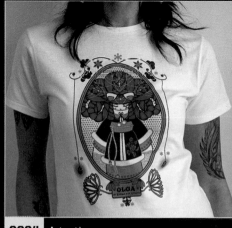

0094 Artcotic

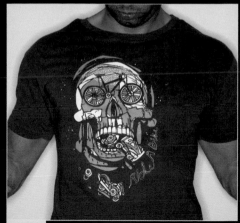

0095 Iskra Print Collective

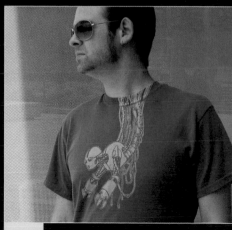

0096 Spaghetti Kiss

It's a SUPA WORLD

SupaKitch

0099 Artcotic

0100 Spaghetti Kiss

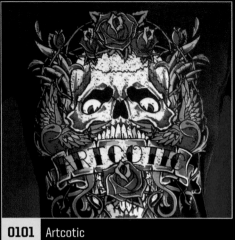

0101 Artcotic

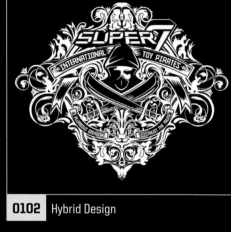

0102 Hybrid Design

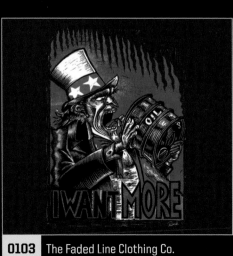

0103 The Faded Line Clothing Co.

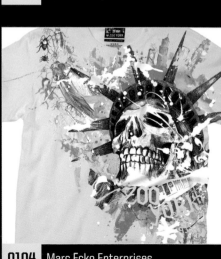

0104 Marc Ecko Enterprises

0105 popidiot

0106 Ames Bros

0107 popidiot

0108 popidiot

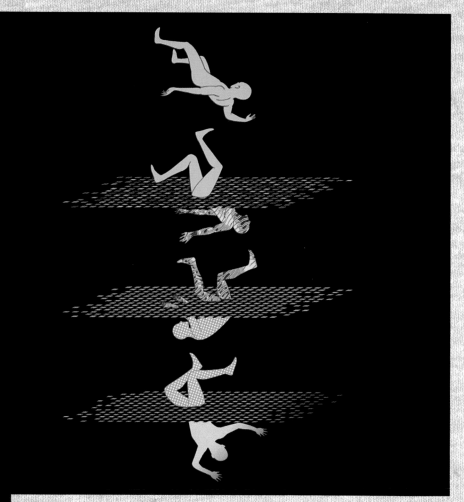

0109 Threadless

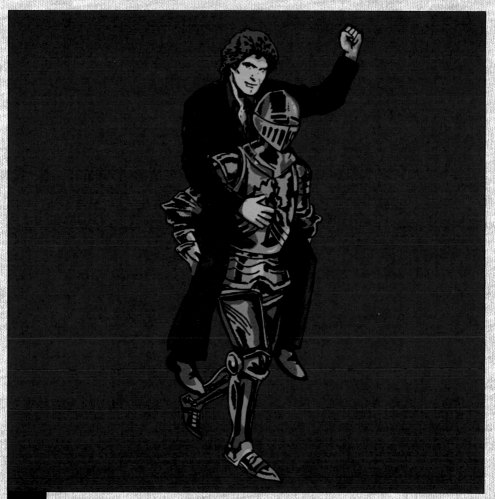

0110 Threadless

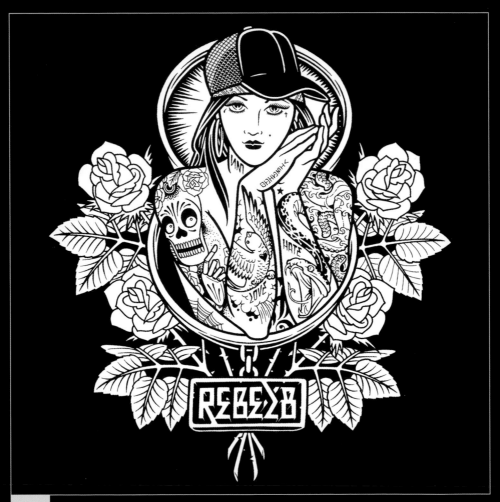

0112 Artcotic

0113 Marc Ecko Enterprises

0114 Artcotic

0115 DA Studios

0116 xeroproject

0117 Squidfire

0118 Squidfire

0119 xeroproject

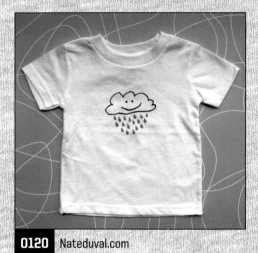

0120 Nateduval.com

0121 Nateduval.com

0122 Loyalty + Blood

0123 Nateduval.com

0124 Threadless

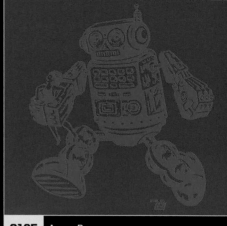

0125 Ames Bros

0126 Ames Bros

0127 Threadless

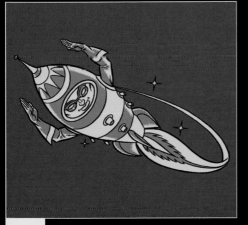

0128 popidiot

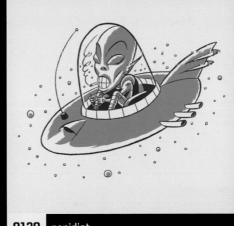

0129 popidiot

0130 popidiot

0131 popidiot

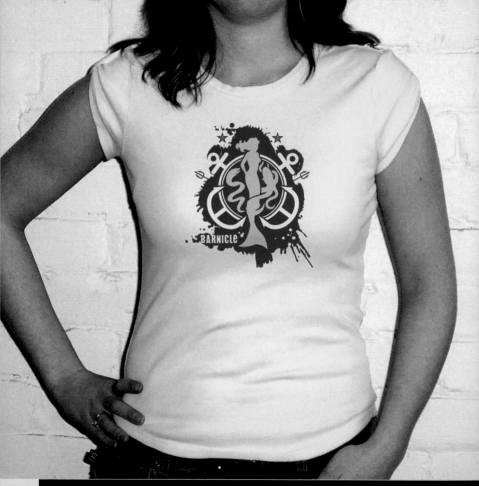

BARNICLE

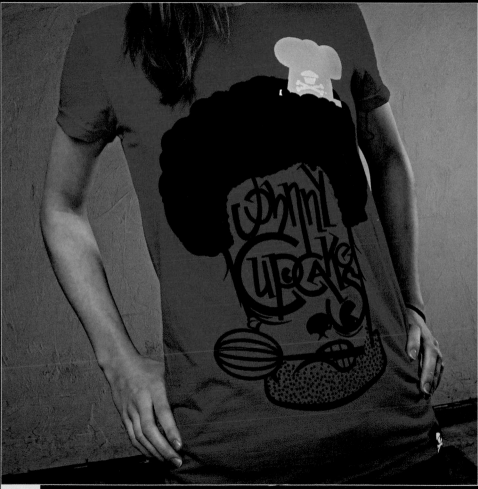

0133 Johnny Cupcakes

0134 christiansen : creative

0135 Alphabet Arm Design

0136 Alphabet Arm Design

0137 Iskra Print Collective

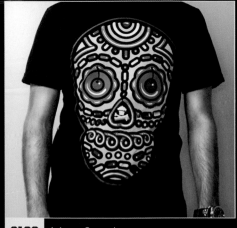

0138 Johnny Cupcakes

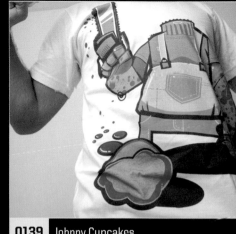

0139 Johnny Cupcakes

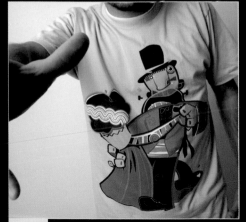

0140 Johnny Cupcakes

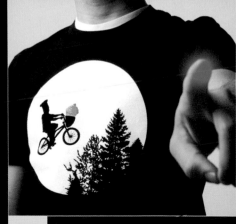

0141 Johnny Cupcakes

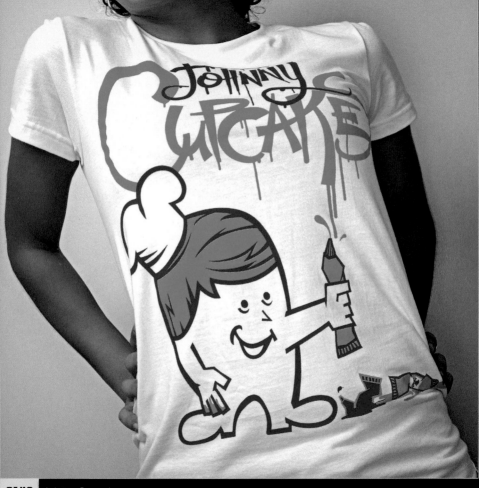

0143 Methane Studios, Inc.

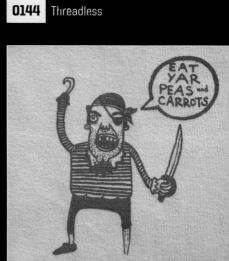

0144 Threadless

0145 Threadless

0146 Red Prairie Press

0147 Ames Bros

0148 Ames Bros

0149 Ames Bros

0150 Hybrid Design

0151 El Jefe Design

0152 El Jefe Design

0153 El Jefe Design

0154 Ames Bros

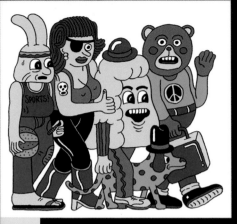

0155 Threadless

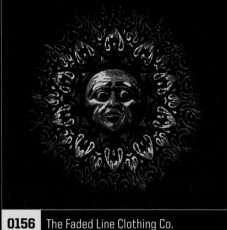

0156 The Faded Line Clothing Co.

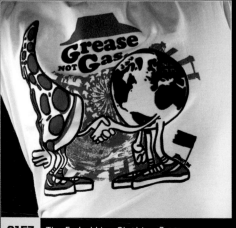

0157 The Faded Line Clothing Co.

0158 Johnny Cupcakes

0159 Ames Bros

0160 Ames Bros

0161 Threadless

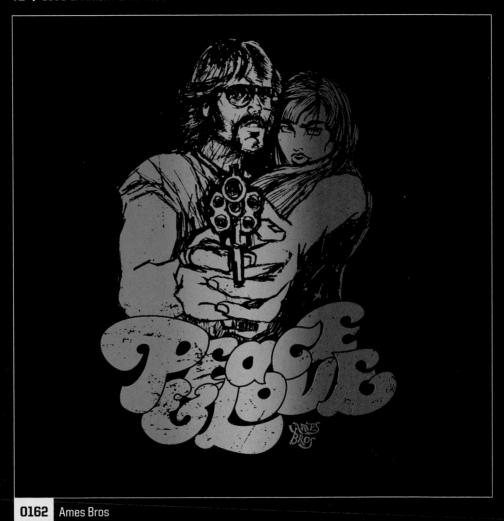

0162 Ames Bros

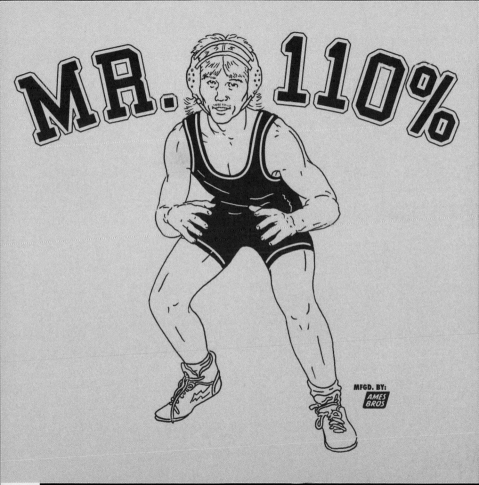

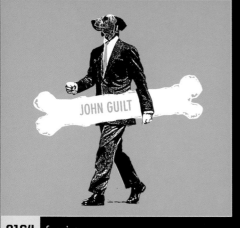

0164 fuszion

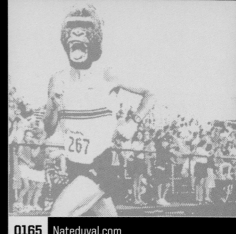

0165 Nateduval.com

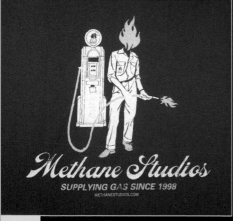

0166 Methane Studios, Inc.

0167 popidiot

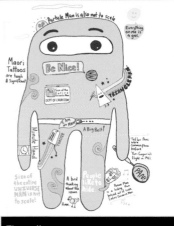

0168 Threadless

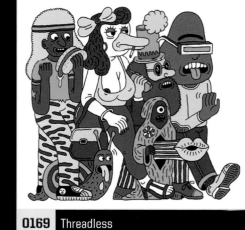

0169 Threadless

0170 Artcotic

0171 Ames Bros

The Faded Line Clothing Co.

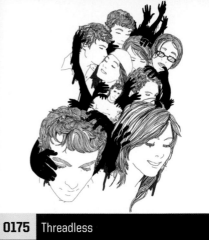

0174 Threadless

0175 Threadless

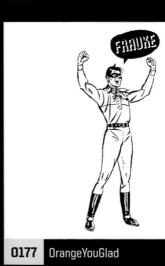

0176 Threadless

0177 OrangeYouGlad

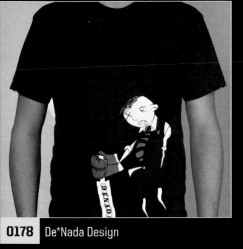

0178 De*Nada Design

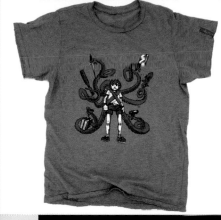

0179 Jonathon Wye, LLC

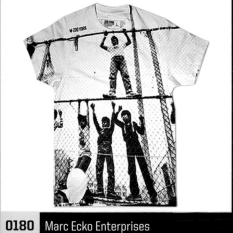

0180 Marc Ecko Enterprises

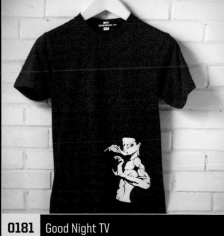

0181 Good Night TV

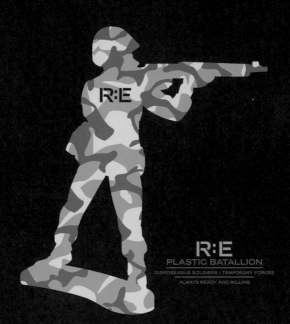

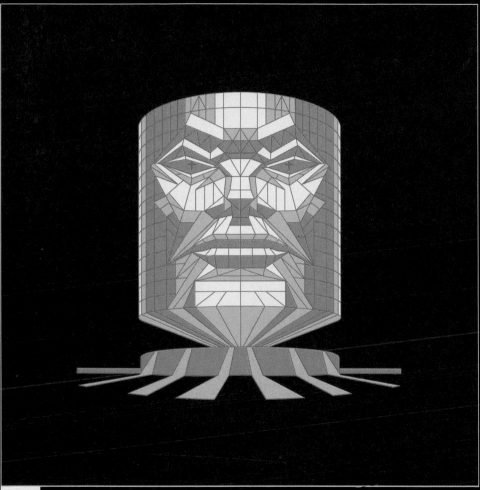

0183 Hybrid Design

0373

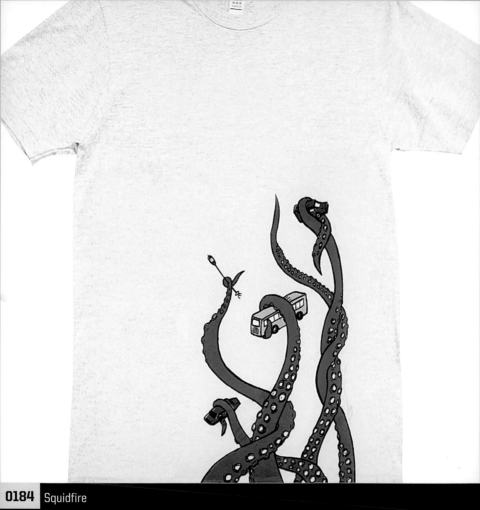

0187 Hybrid Design

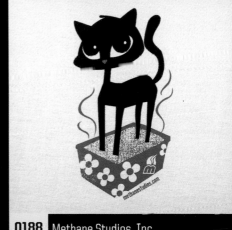

0188 Methane Studios, Inc.

0189 Hybrid Design

0190 Ames Bros

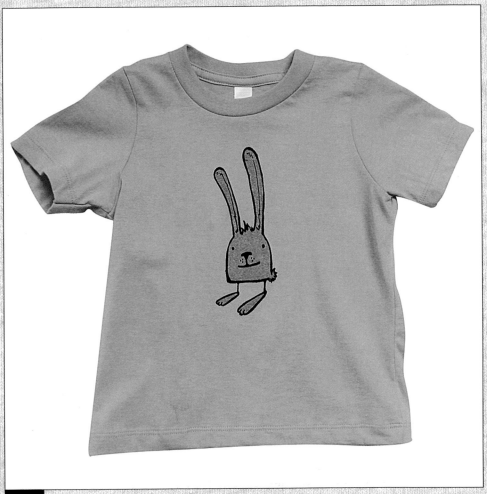

0191 Squidfire

0192 Squidfire

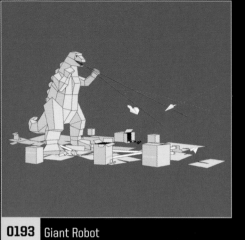

0193 Giant Robot

0194 Ames Bros

0195 Threadless

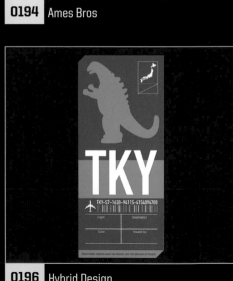

0196 Hybrid Design

0197 Ames Bros

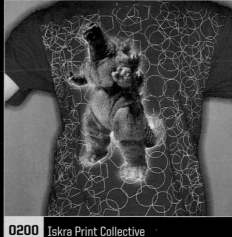

0198 The Faded Line Clothing Co.

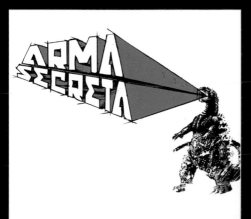

0199 Boss Construction

0200 Iskra Print Collective

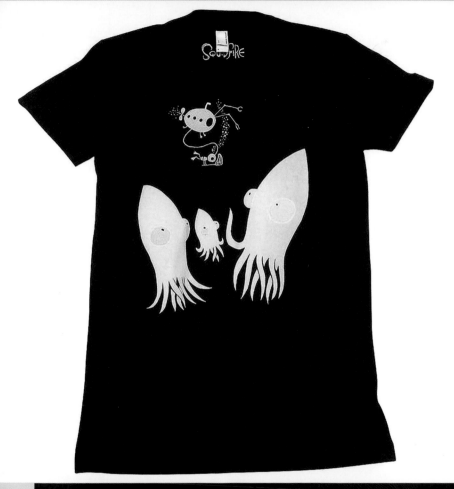

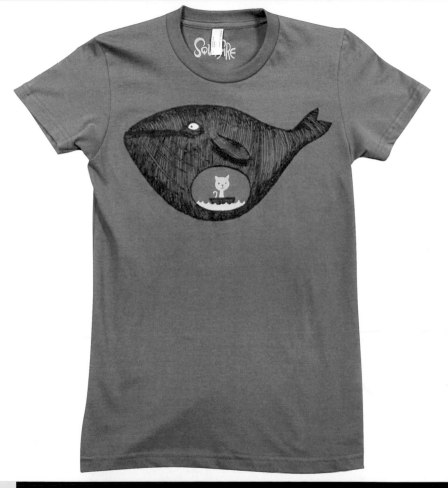

0203 Ames Bros

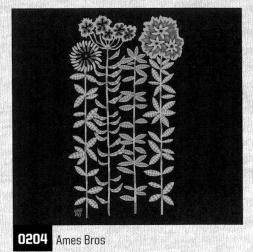

0204 Ames Bros

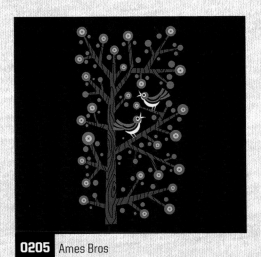

0205 Ames Bros

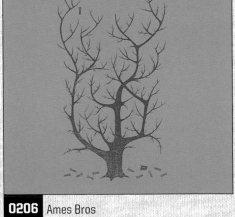

0206 Ames Bros

STATIC OF THE *Gods*

0207 Alphabet Arm Design

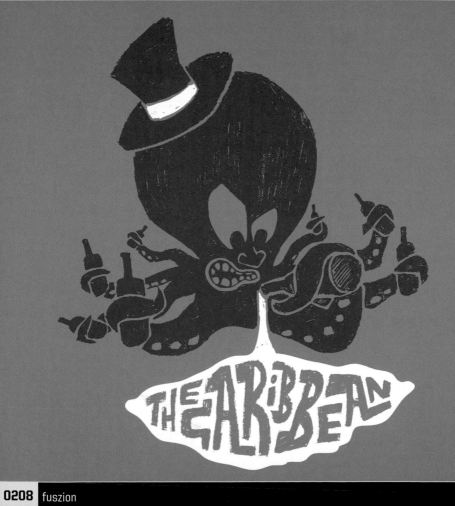

THE CARIBBEAN

0210 Fullblastinc.com

0211 Fullblastinc.com

0212 Lucky Bunny Visual Communications

0213 Lucky Bunny Visual Communications

0214 Red Prairie Press

0215 Go Welsh

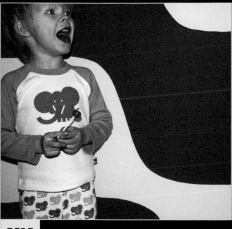

0216 Banker Wessel

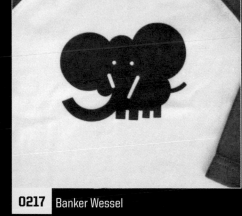

0217 Banker Wessel

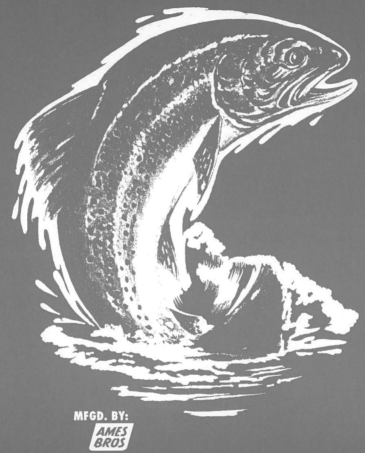

MFGD. BY:
AMES BROS

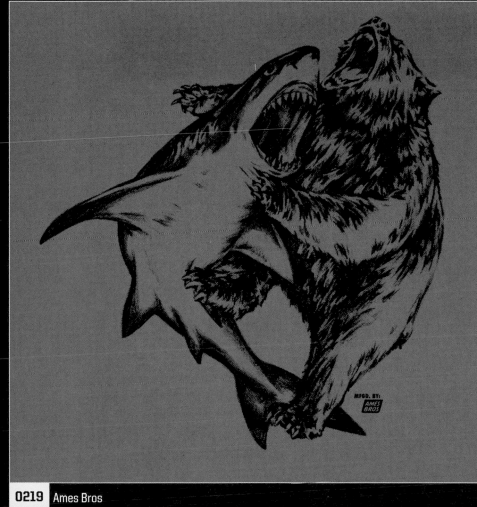

MFGD. BY:
AMES BROS

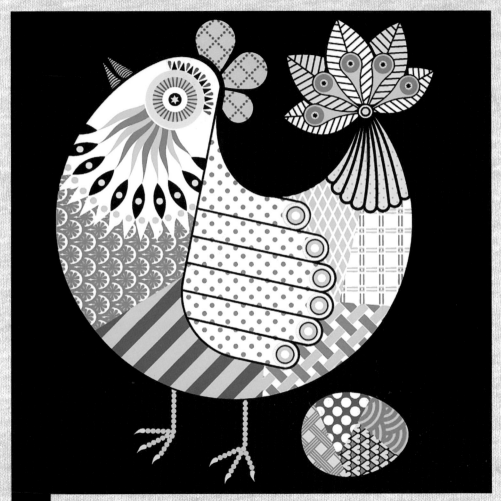

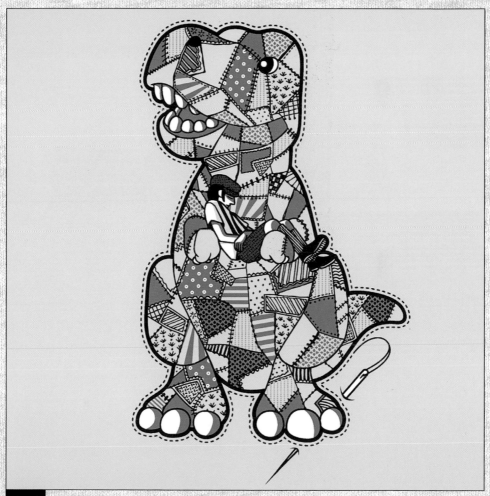

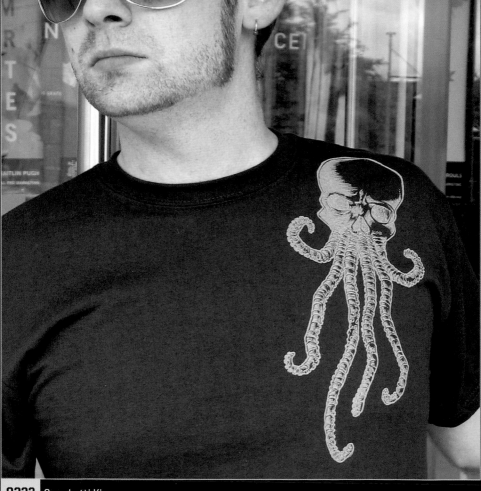

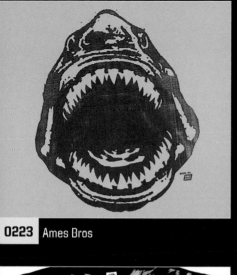

0223 Ames Bros

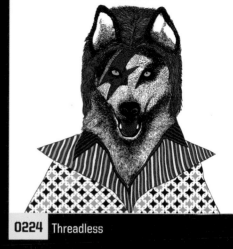

0224 Threadless

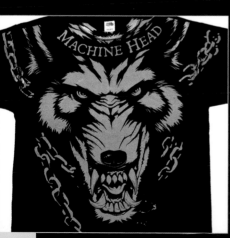

0225 DA Studios

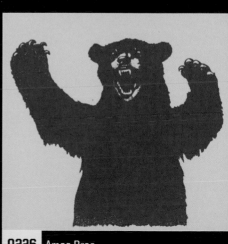

0226 Ames Bros

0228 Threadless

0229 Threadless

0230 Methane Studios, Inc.

0231 Jonathon Wye, LLC

0232 Ames Bros

PORTERHOUSE VEGAN

0234 Go Welsh

0235 Go Welsh

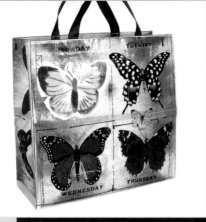

0236 Blue Q

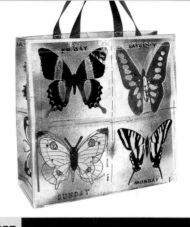

0237 Blue Q

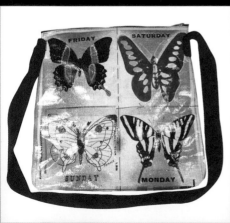

0238 Blue Q

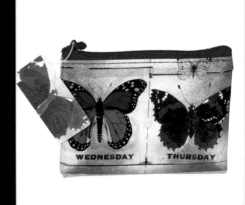

0239 Blue Q

0240 Blue Q

0241 Blue Q

0242 Blue Q

0243 Blue Q

horse

chicken

0245 Go Welsh

pig

0247 Go Welsh

0249 Threadless

0250 Hybrid Design

0251 Hybrid Design

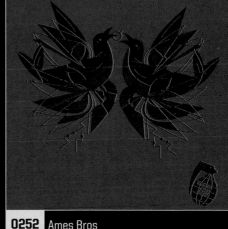

0252 Ames Bros

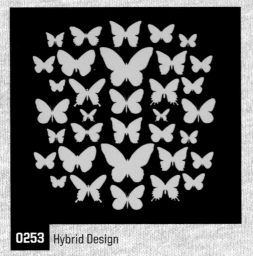

0253 Hybrid Design

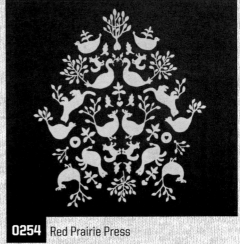

0254 Red Prairie Press

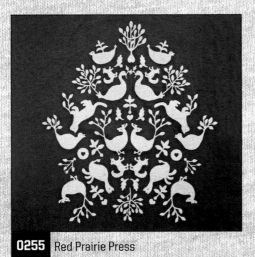

0255 Red Prairie Press

0256 Hybrid Design

0257 Threadless

0258 Hybrid Design

0259 Hybrid Design

0260 Hybrid Design

0261 Hybrid Design

0262 Red Prairie Press

0263 Red Prairie Press

0264 Red Prairie Press

0265 Ames Bros

0268 Blue Q

0269 Blue Q

0270 Blue Q

0271 Blue Q

0272 Blue Q

0273 Blue Q

0274 Blue Q

0275 Blue Q

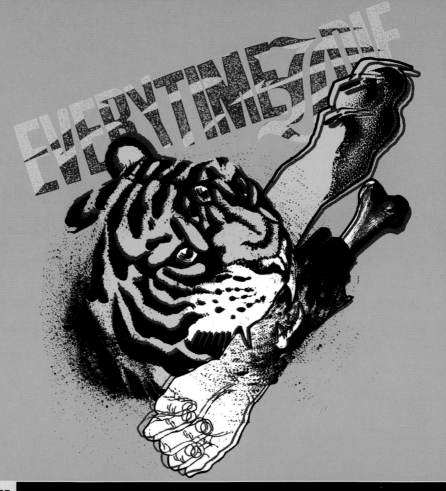

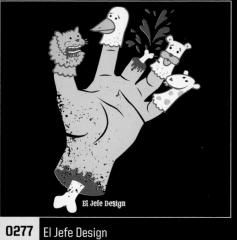

0277 El Jefe Design

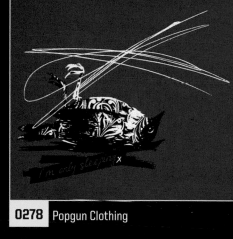

0278 Popgun Clothing

0279 Artcotic

Threadless

0280 Threadless

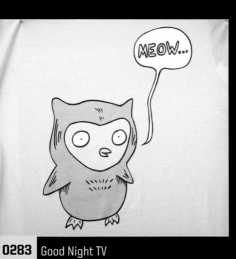

0281 Red Prairie Press

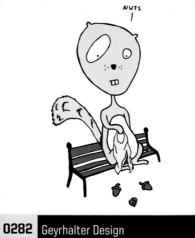

0282 Geyrhalter Design

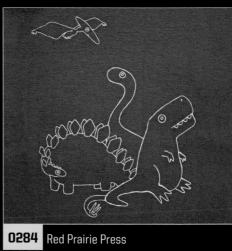

0283 Good Night TV

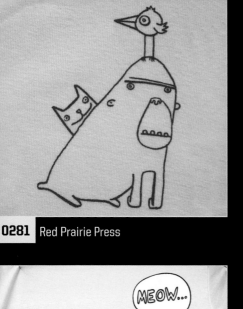

0284 Red Prairie Press

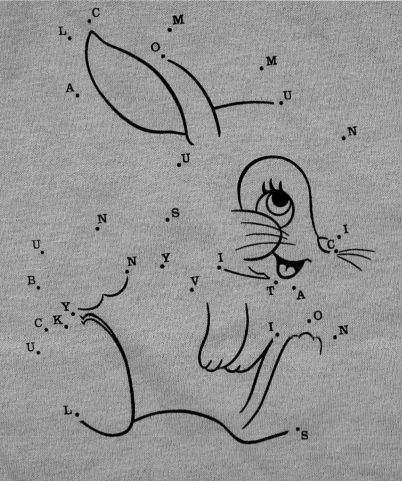

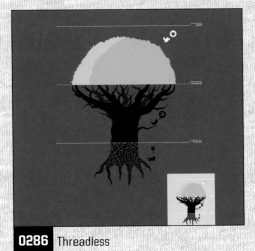

0286 Threadless

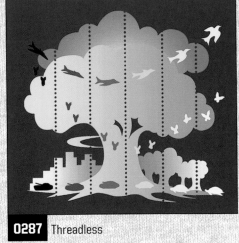

0287 Threadless

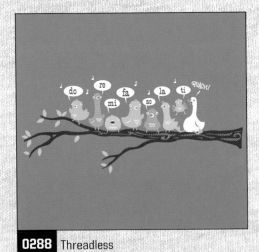

0288 Threadless

0289 Threadless

0290 Threadless

0291 Ames Bros

0292 Alphabet Arm Design

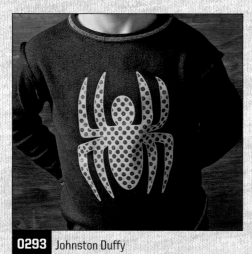

0293 Johnston Duffy

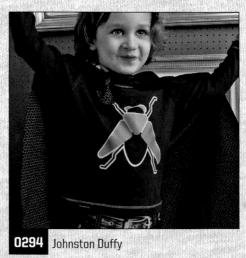

0294 Johnston Duffy

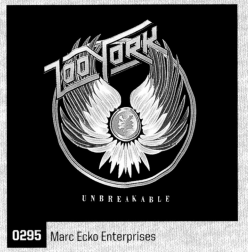

0295 Marc Ecko Enterprises

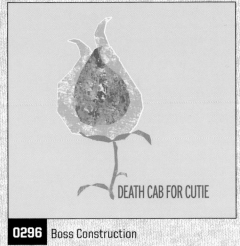

0296 Boss Construction

0297 Leia Bell Posters & Fine Art

0298 Di Depux

0299 Threadless

0300 Threadless

0301 Hero Design Studio

0302 Hero Design Studio

Fold to the arrows for a surpise!

0303 Threadless

0304 Threadless

0305 Threadless

0306 Threadless

0307 Go Welsh

0308 Go Welsh

0309 Threadless

0310 Hybrid Design

0311 Hybrid Design

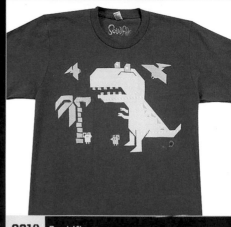

0312 Squidfire

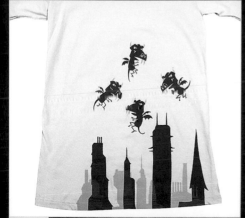

0313 Squidfire

0314 Squidfire

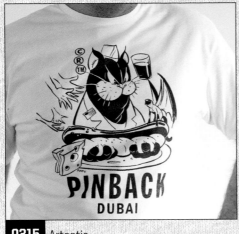

0315 Artcotic

0316 popidiot

0317 Ames Bros

0318 Artcotic

0319 Threadless

0320 Hero Design Studio

0321 REBEL8

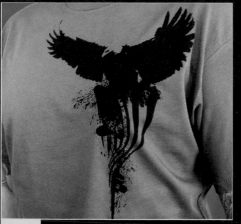

0322 Artcotic

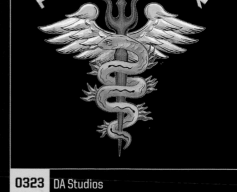

0323 DA Studios

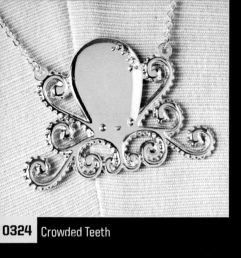

0324 Crowded Teeth

0325 popidiot

0326 Ames Bros

0327 Alphabet Arm Design

0328 Nateduval.com

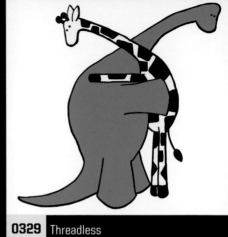

0329 Threadless

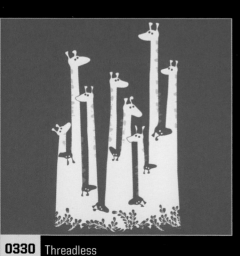

0330 Threadless

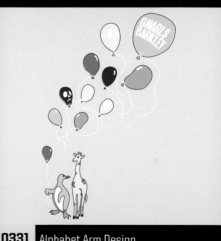

0331 Alphabet Arm Design

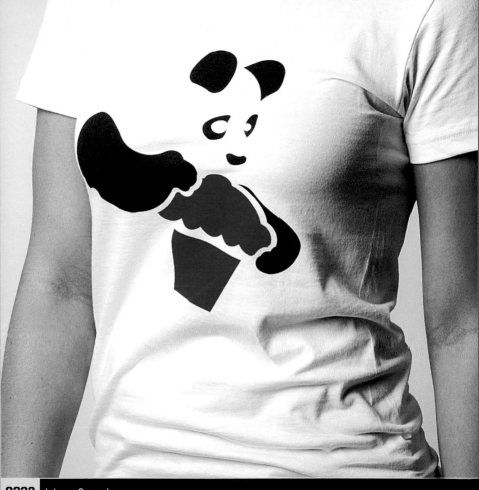

0333 Leia Bell Posters & Fine Art

0334 Threadless

0335 Hero Design Studio

0336 Lucky Bunny Visual Communications

0337 Ames Bros

0338 Ames Bros

0339 Blue Q

0340 Blue Q

0341 Pappas MacDonnell, Inc

0342 EBD

0343 Red Prairie Press

0344 Ames Bros

0345 Johnny Cupcakes

0346 Methane Studios, Inc.

0347 Threadless

0348 Firebelly Design

0349 Craze One. Clothing™/ No Coast Design™

0350 Threadless

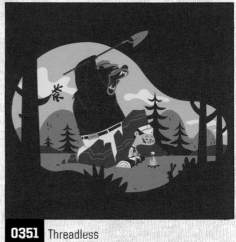

0351 Threadless

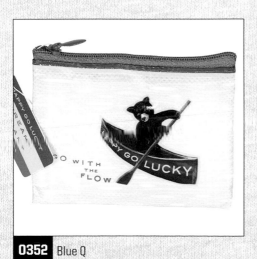

0352 Blue Q

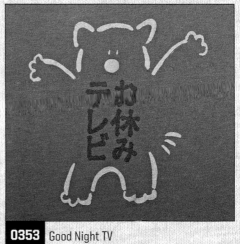

0353 Good Night TV

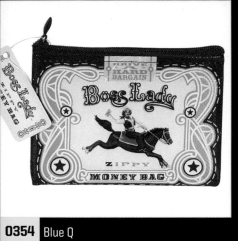

0354 Blue Q

0355 Nateduval.com

0356 Threadless

0357 Blue Q

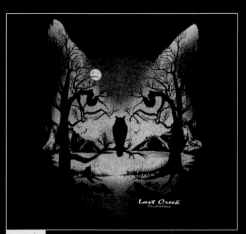

0358 T-Shirt International, Inc

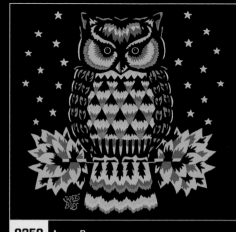

0359 Ames Bros

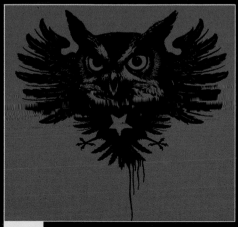

0360 Ames Bros

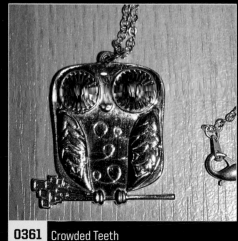

0361 Crowded Teeth

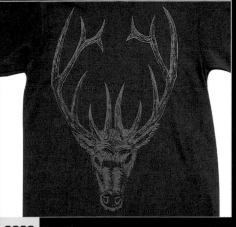

0363 Squidfire

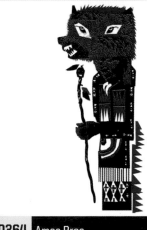

0364 Ames Bros

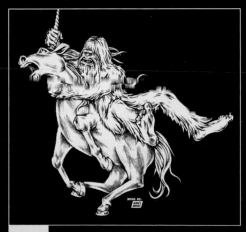

0365 Ames Bros

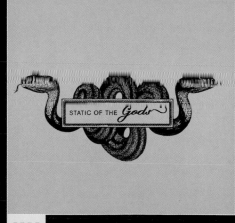

0366 Alphabet Arm Design

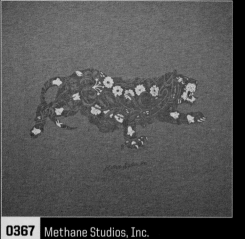

0367 Methane Studios, Inc.

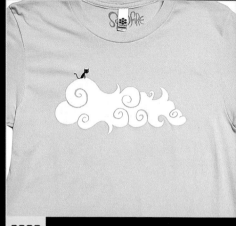

0368 Squidfire

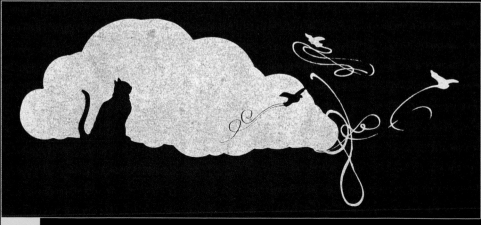

0369 Red Prairie Press

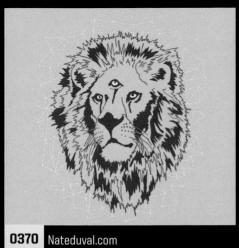

0370 Nateduval.com

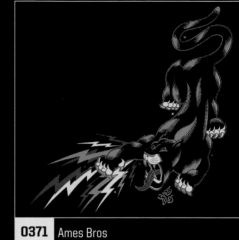

0371 Ames Bros

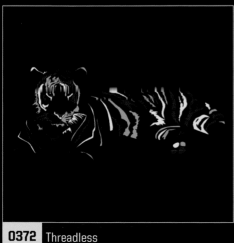

0372 Threadless

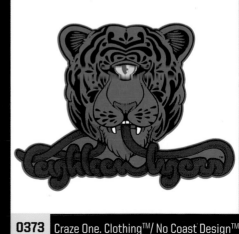

0373 Craze One. Clothing™/ No Coast Design™

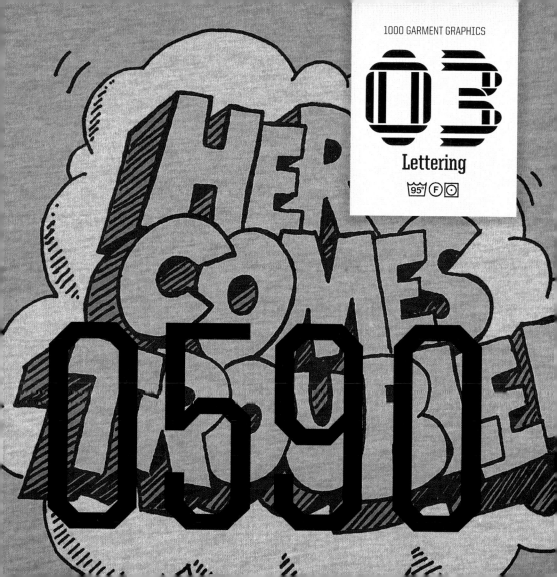

03

Lettering

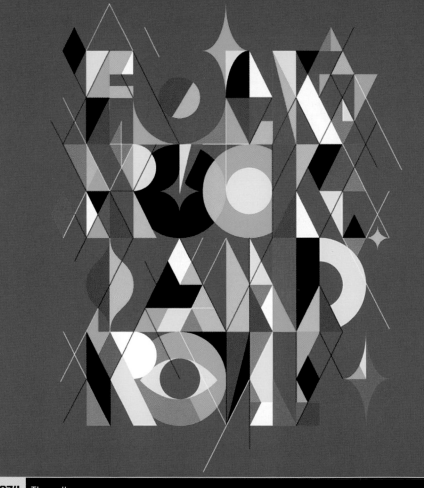

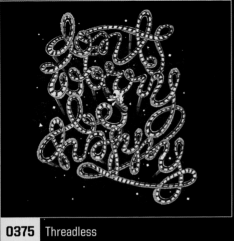

0375 Threadless

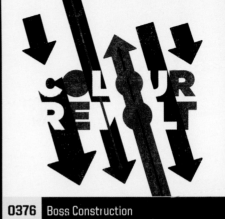

0376 Boss Construction

0377 Threadless

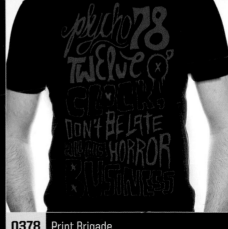

0378 Print Brigade

0379 Alphabet Arm Design

0380 Alphabet Arm Design

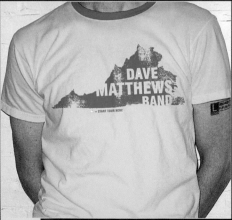

0381 Alphabet Arm Design

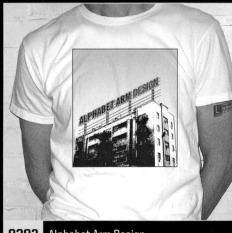

0382 Alphabet Arm Design

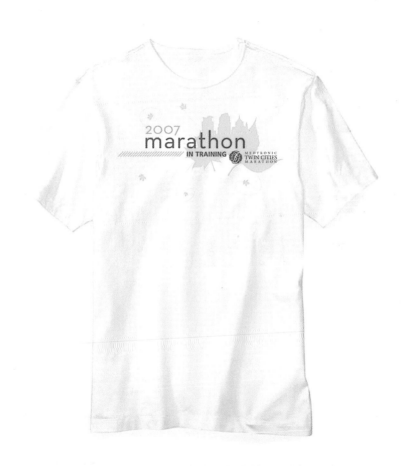

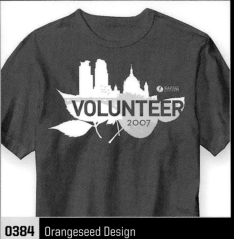

0384 Orangeseed Design

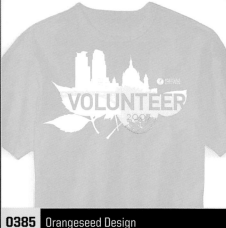

0385 Orangeseed Design

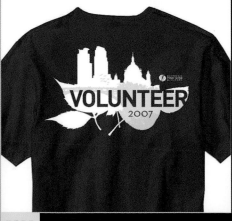

0386 Orangeseed Design

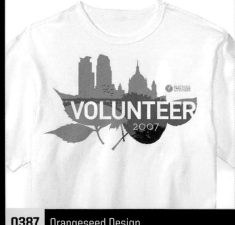

0387 Orangeseed Design

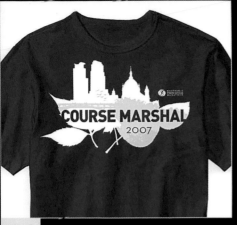

0388 Orangeseed Design

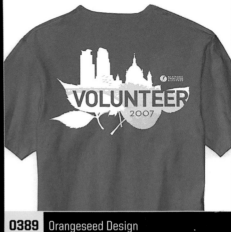

0389 Orangeseed Design

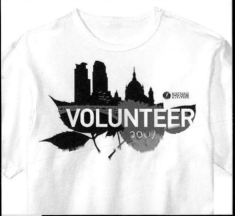

0390 Orangeseed Design

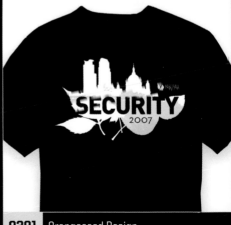

0391 Orangeseed Design

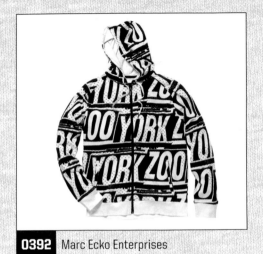

0392 Marc Ecko Enterprises

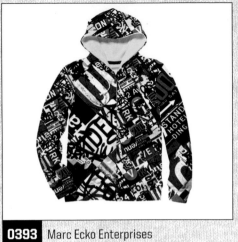

0393 Marc Ecko Enterprises

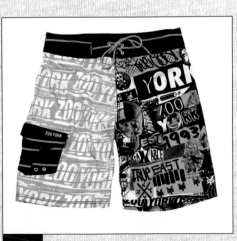

0394 Marc Ecko Enterprises

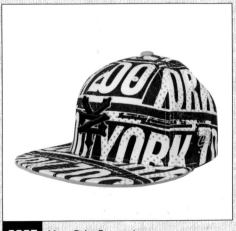

0395 Marc Ecko Enterprises

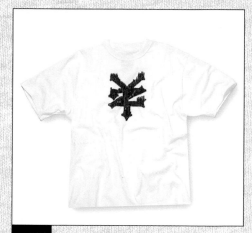

0396 Marc Ecko Enterprises

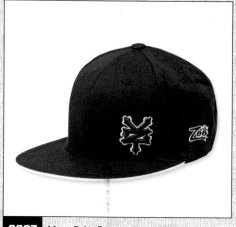

0397 Marc Ecko Enterprises

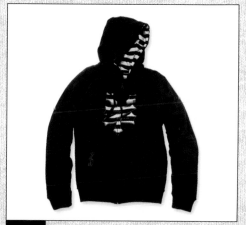

0398 Marc Ecko Enterprises

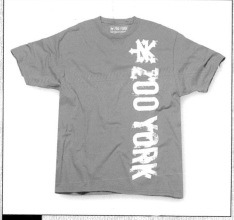

0399 Marc Ecko Enterprises

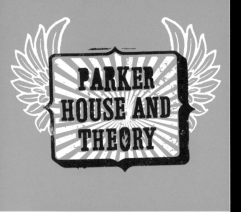

0400 Alphabet Arm Design

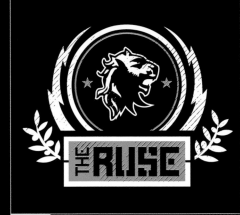

0401 Alphabet Arm Design

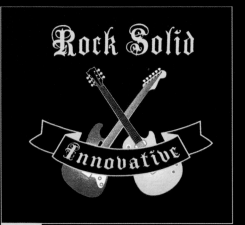

0402 INNOVATIVE interfaces

0403 Hero Design Studio

JACKASS

Ames Bros

0407 Alphabet Arm Design

0408 Alphabet Arm Design

0409 Alphabet Arm Design

0410 Alphabet Arm Design

0411 Alphabet Arm Design

GAS·HOLE

MFGD. BY:
AMES BROS

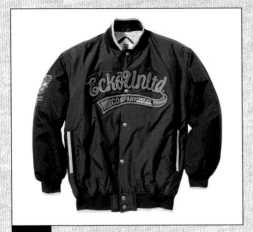

0414 Marc Ecko Enterprises

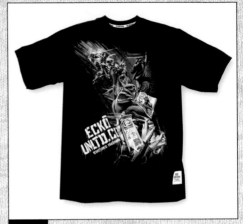

0415 Marc Ecko Enterprises

0416 Marc Ecko Enterprises

0417 Marc Ecko Enterprises

0418 Marc Ecko Enterprises

0420 Giorgio Davanzo Design

0421 Marc Ecko Enterprises

0422 Marc Ecko Enterprises

0423 Marc Ecko Enterprises

0424 Marc Ecko Enterprises

0425 Marc Ecko Enterprises

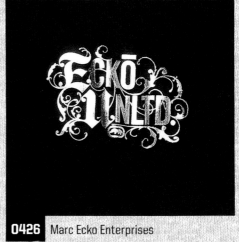

0426 Marc Ecko Enterprises

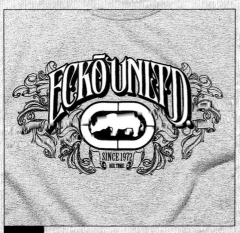

0427 Marc Ecko Enterprises

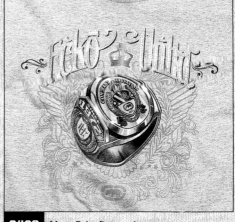

0428 Marc Ecko Enterprises

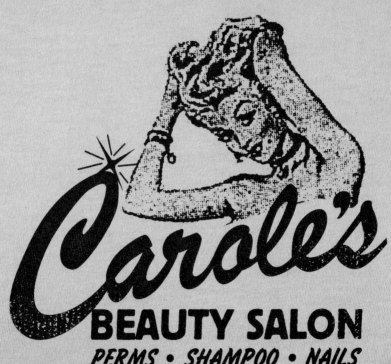

Carole's

BEAUTY SALON

PERMS • SHAMPOO • NAILS

Methane Studios, Inc.

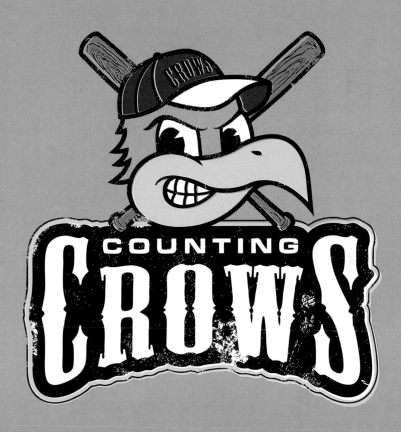

0431 ATX/Aesthetix

0433 ATX/Aesthetix

0432 ATX/Aesthetix

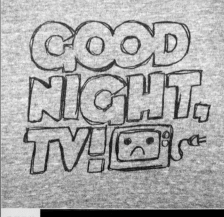

0434 Good Night TV

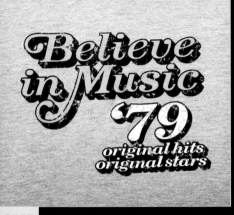

0435 Good Night TV

McCoca ★ MART
YOU ARE THE ◎

0436 Good Night TV

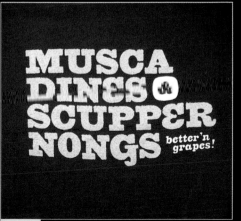

0437 Good Night TV

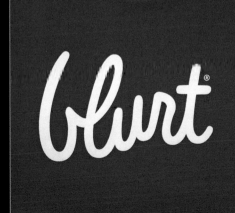

0438 Go Welsh

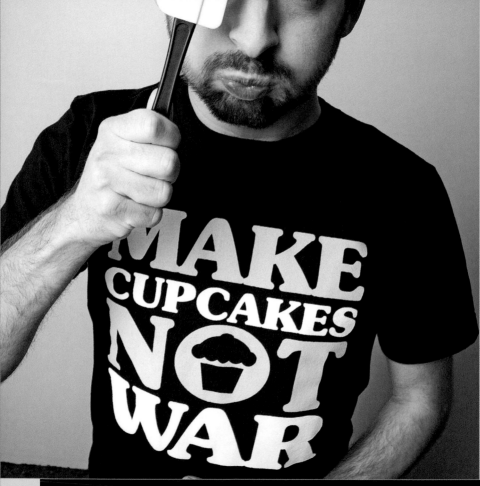

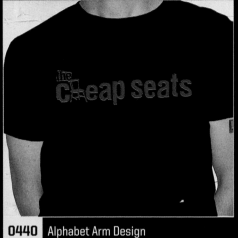

0440 Alphabet Arm Design

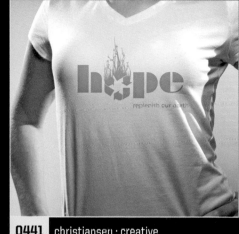

0441 christiansen : creative

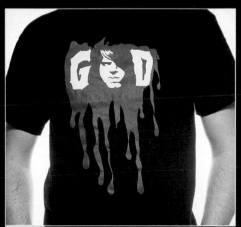

0442 Print Brigade

0443 Studio International

0444 Ames Bros

0445 Ames Bros

0446 Ames Bros

0447 Ames Bros

0453 Threadless

0454 Threadless

0455 Threadless

0456 Threadless

0457 Threadless

IF I HEAR THE WORD 'GREEN'

ONE MORE TIME I SWEAR

I WILL SWITCH BACK TO

P L A S T I C

0458 Geyrhalter Design

0459 Ames Bros

0460 Ames Bros

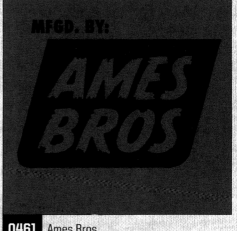

0461 Ames Bros

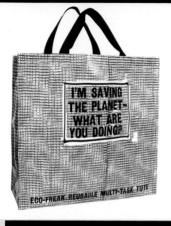

0462 Blue Q

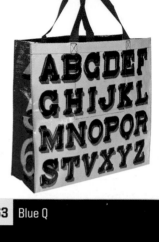

0463 Blue Q

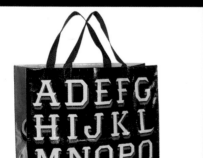

0464 Blue Q

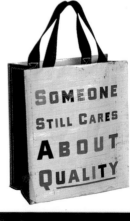

0465 Blue Q

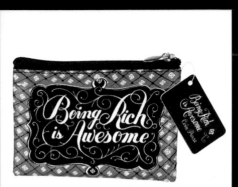

0466 Blue Q

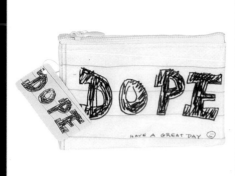

0467 Blue Q

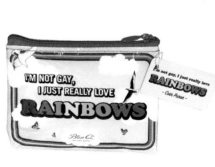

0468 Blue Q

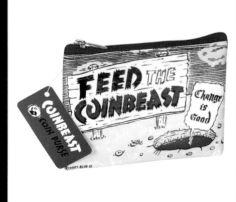

0469 Blue Q

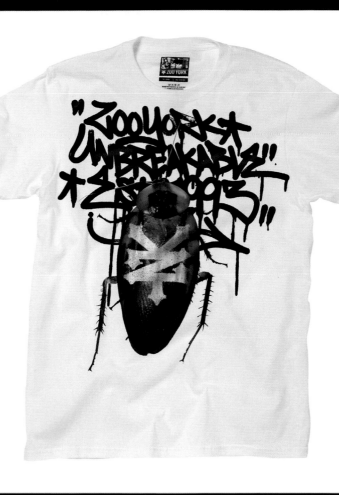

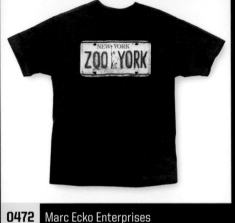

0472 Marc Ecko Enterprises

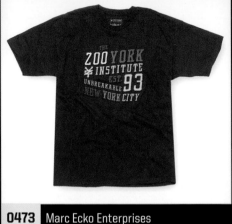

0473 Marc Ecko Enterprises

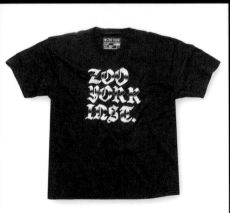

0474 Marc Ecko Enterprises

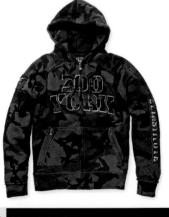

0475 Marc Ecko Enterprises

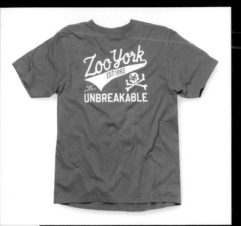

0476 Marc Ecko Enterprises

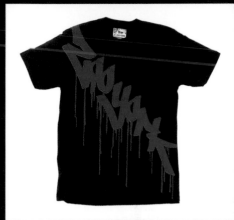

0477 Marc Ecko Enterprises

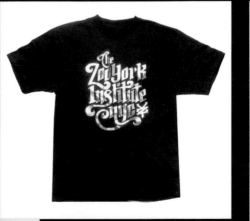

0478 Marc Ecko Enterprises

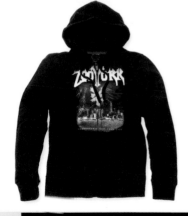

0479 Marc Ecko Enterprises

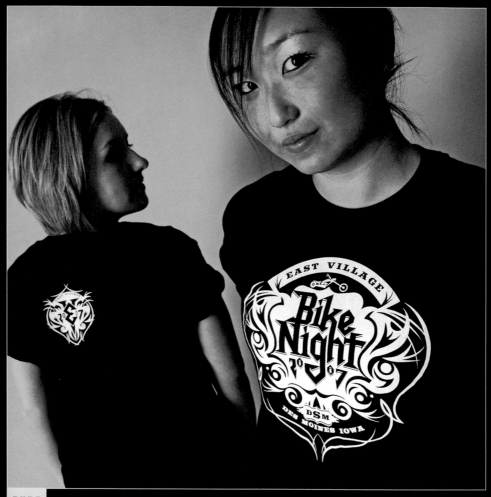

0480 Sayles Graphic Design

0481 Black Van Industries

0482 Black Van Industries

0483 Black Van Industries

0484 Black Van Industries

0485 Iskra Print Collective

0486 EBD

0487 Iskra Print Collective

0488 Iskra Print Collective

0489 Iskra Print Collective

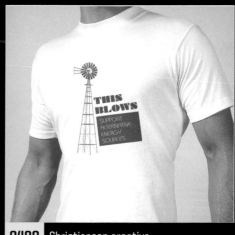

0490 Christiansen:creative

0491 DA Studios

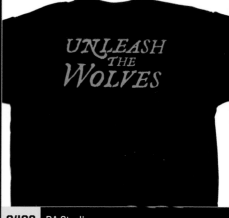

0492 DA Studios

I ♥ THE FORCE

0493 Hybrid Design

I 🌲 PDX

0494 Hybrid Design

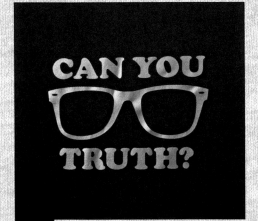

0495 ATX/Aesthetix

0496 Ames Bros

0497 ATX/Aesthetix

0498 Craze One. Clothing™/No Coast Design™

0499 Print Brigade

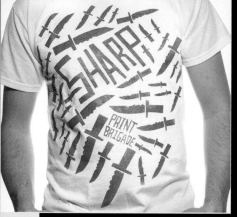

0500 Print Brigade

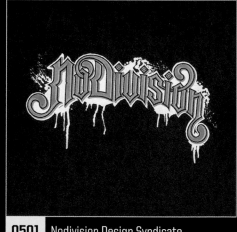

0501 Nodivision Design Syndicate

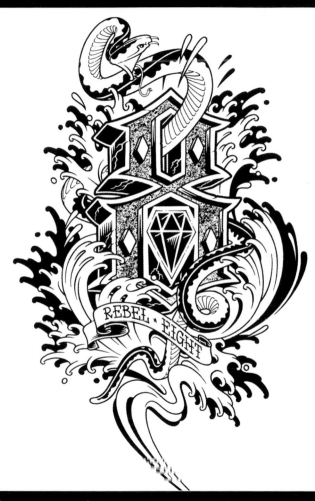

0502 REBEL8

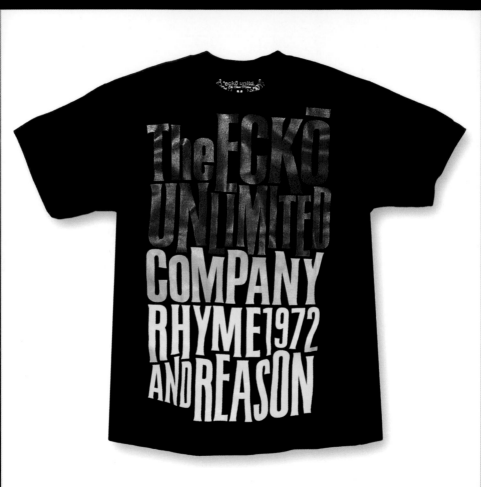

0504 Marc Ecko Enterprises

0505 Marc Ecko Enterprises

0506 Marc Ecko Enterprises

0507 Marc Ecko Enterprises

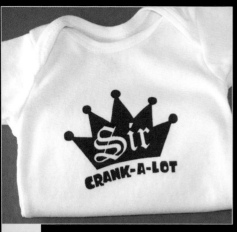

0508 Clay McIntosh Creative

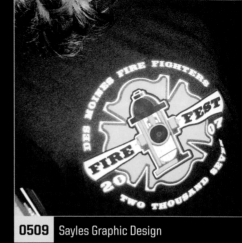

0509 Sayles Graphic Design

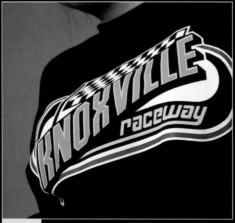

0510 Sayles Graphic Design

0511 S Design Inc.

0512 christiansen : creative

0513 Iskra Print Collective

0514 EBD

0515 christiansen : creative

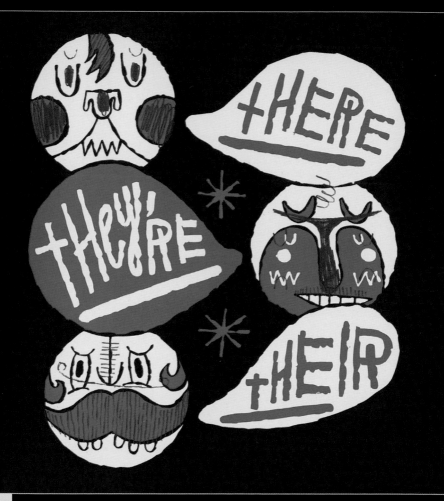

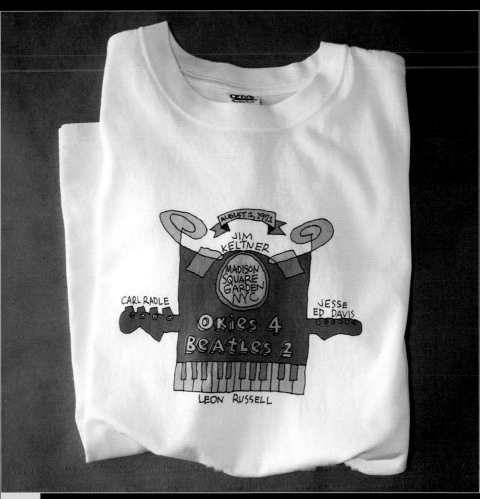

0518 Blue Q

0519 Wing Chan Design, Inc.

0520 Blue Q

0521 Blue Q

0522 Blue Q

0523 De*Nada Design

IT'S OUR WORLD
STAND
UP (now)
AND START
SAVING IT

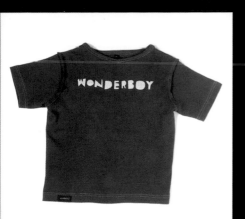

0525 Johnston Duffy

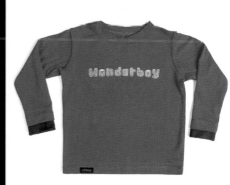

0526 Johnston Duffy

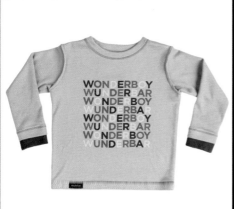

0527 Johnston Duffy

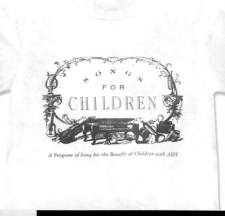

0528 Wing Chan Design, Inc.

0529 Boss Construction

0530 Lucky Bunny Visual Communications

0531 Alphabet Arm Design

0532 El Jefe Design

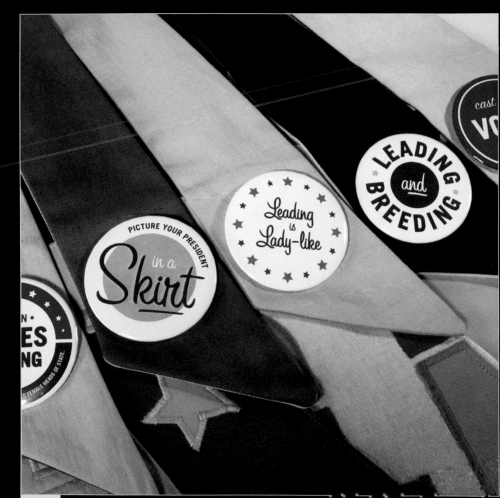

0533 Kimiyo Nakatsui

0535 Johnston Duffy

0536 Iskra Print Collective

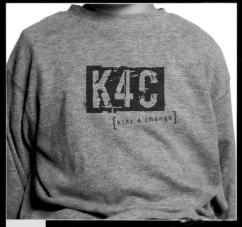

0537 christiansen : creativa

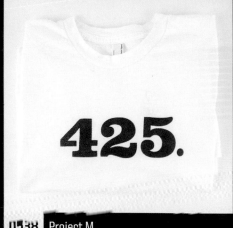

0538 Project M

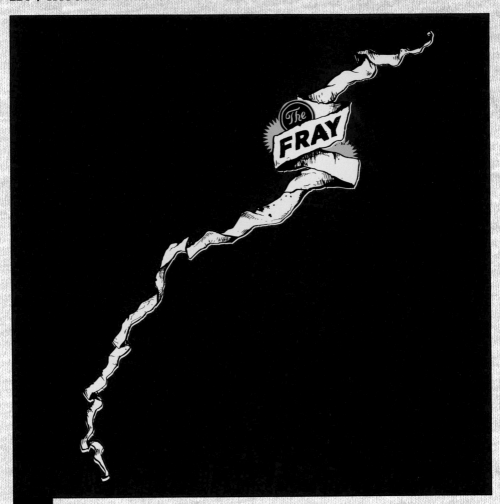

0539 Alphabet Arm Design

0540 Alphabet Arm Design

0541 xeroproject

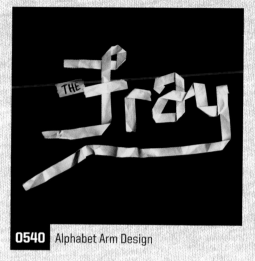

0542 ATX/ Aesthetix

0543 Alphabet Arm Design

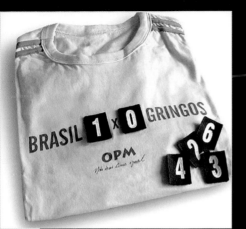

0545 OPM–Oficina de Propaganda e Marketing

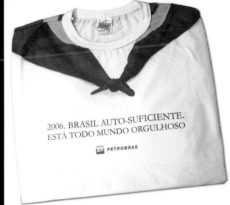

0546 OPM–Oficina de Propaganda e Marketing

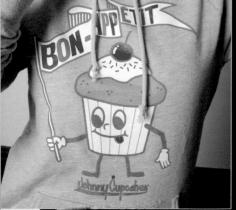

0547 Johnny Cupcakes

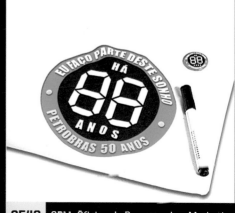

0548 OPM–Oficina de Propaganda e Marketing

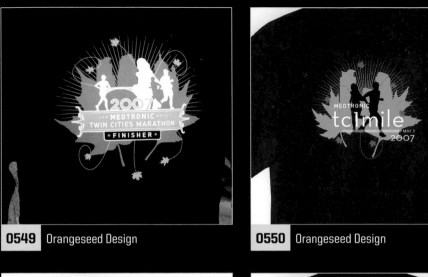

0549 Orangeseed Design

0550 Orangeseed Design

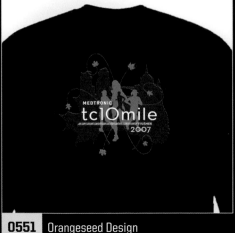

0551 Orangeseed Design

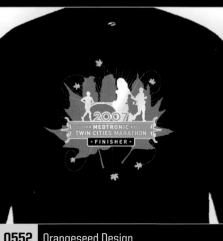

0552 Orangeseed Design

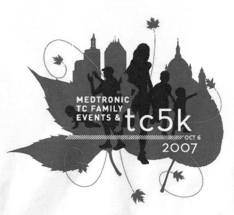

0557 Orangeseed Design

0558 Hybrid Design

0559 Hybrid Design

0560 Hybrid Design

0561 Hybrid Design

0562 Giant Robot

0563 Giant Robot

0564 Hybrid Design

0565 El Jefe Design

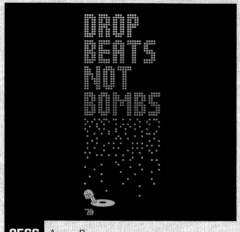

0566 Ames Bros

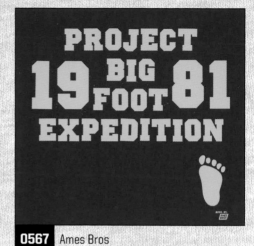

0567 Ames Bros

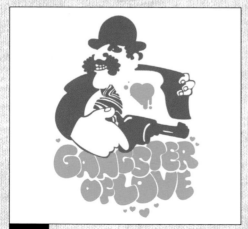

0568 Ames Bros

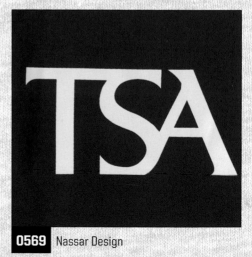

0569 Nassar Design

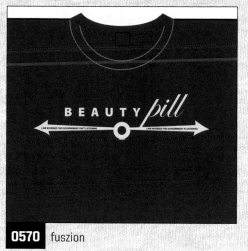

0570 fuszion

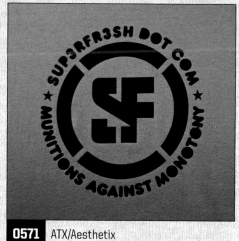

0571 ATX/Aesthetix

0572 Threadless

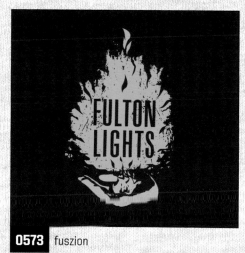

0573 fuszion

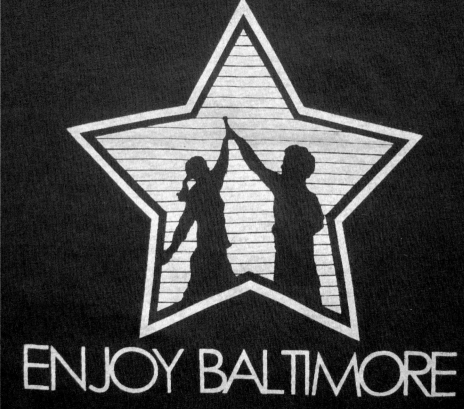

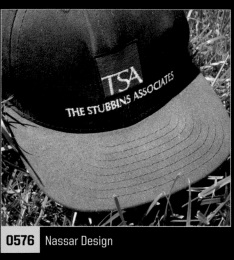

0576 Nassar Design

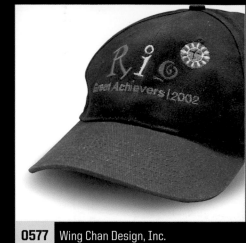

0577 Wing Chan Design, Inc.

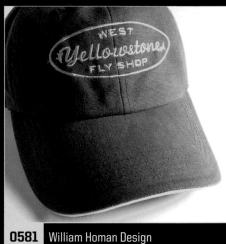

0580 William Homan Design

0581 William Homan Design

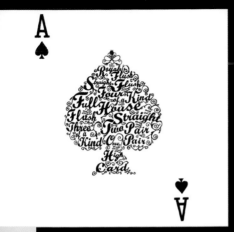

0578 Threadless

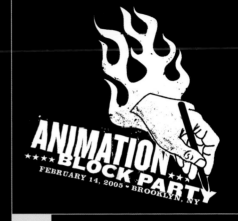

0579 El Jefe Design

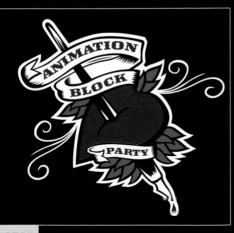

0582 El Jefe Design

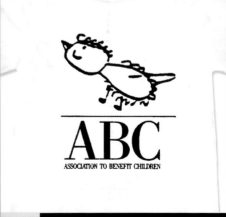

0583 Wing Chan Design, Inc.

0584 Alphabet Arm Design

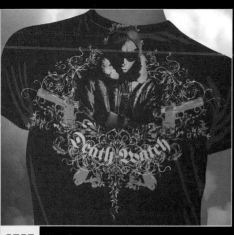

0585 Hive Creative

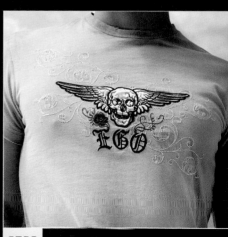

0586 Hive Creative

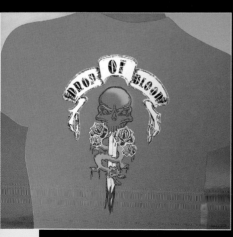

0587 Hive Creative

0588 Hive Creative

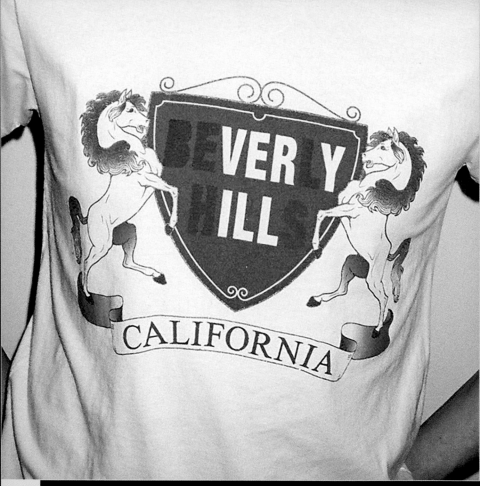

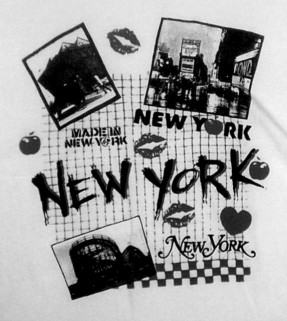

04

Pattern

0766

FINES

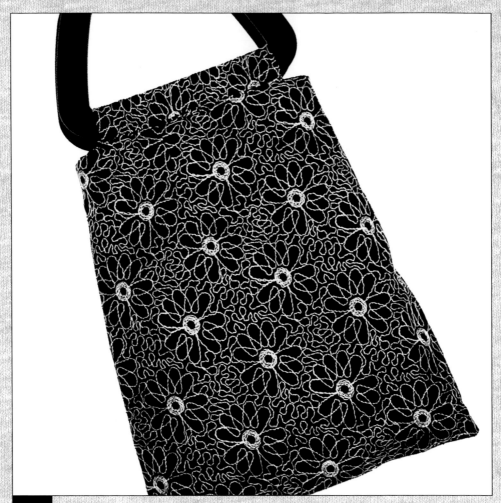

0591 Purses by Pants

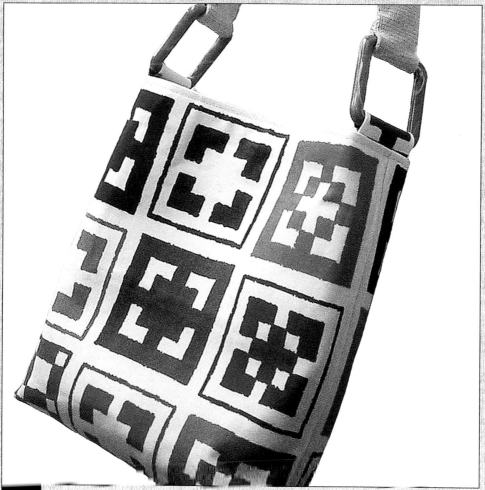

0592 Purses by Pants

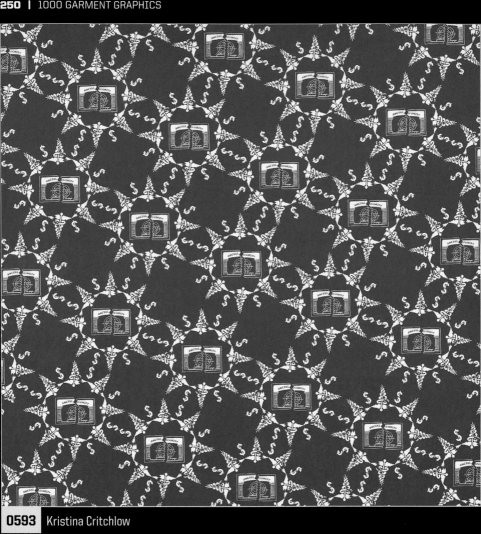

0593 Kristina Critchlow

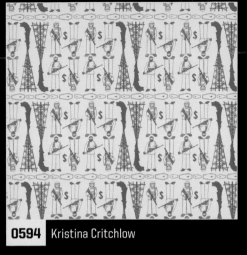

0594 Kristina Critchlow

0595 Kristina Critchlow

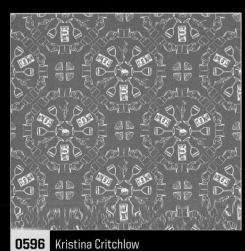

0596 Kristina Critchlow

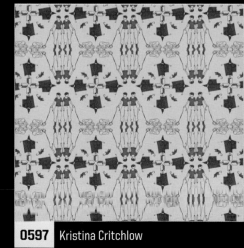

0597 Kristina Critchlow

0598 Addict LTD

0599 Addict LTD

0600 Addict LTD

0601 Addict LTD

0602 Marc Ecko Enterprises

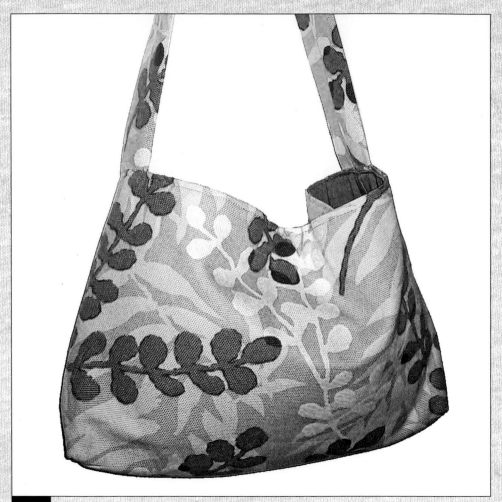

0603 Purses by Pants

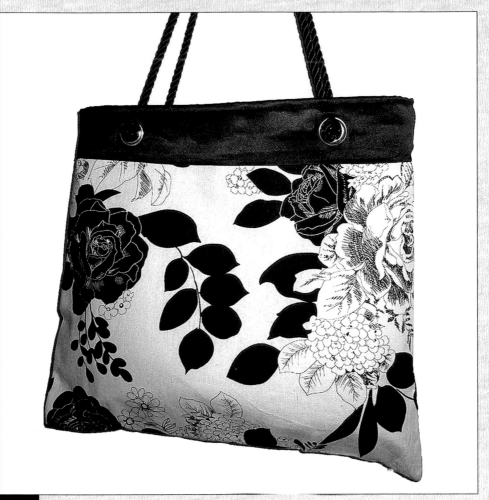

0604 Purses by Pants

0605 Marc Ecko Enterprises

0606 Marc Ecko Enterprises

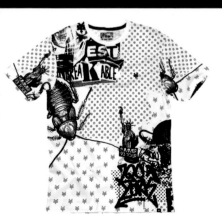

0607 Marc Ecko Enterprises

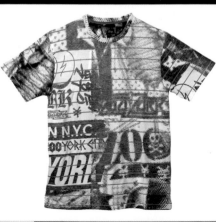

0608 Marc Ecko Enterprises

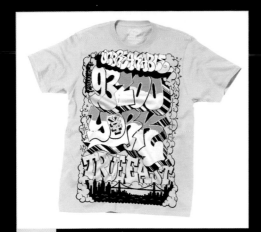

0609 Marc Ecko Enterprises

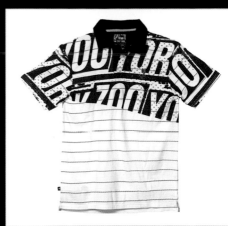

0610 Marc Ecko Enterprises

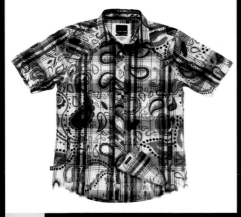

0611 Marc Ecko Enterprises

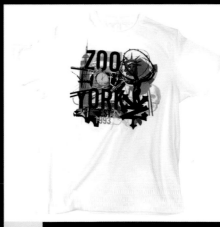

0612 Marc Ecko Enterprises

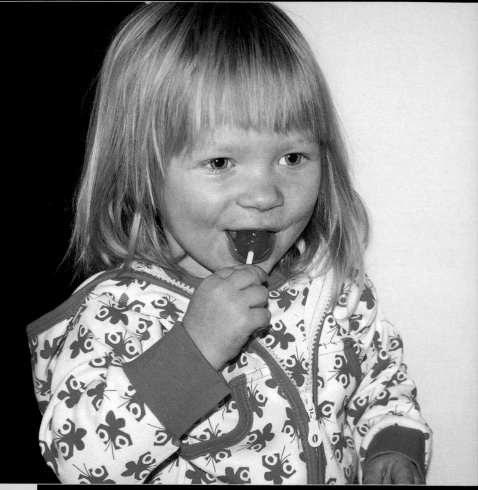

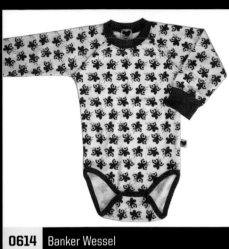

0614 Banker Wessel

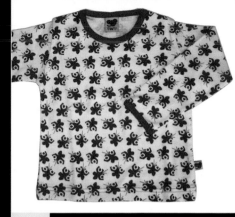

0615 Banker Wessel

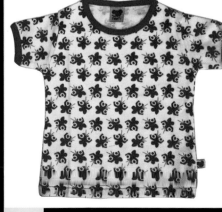

0616 Banker Wessel

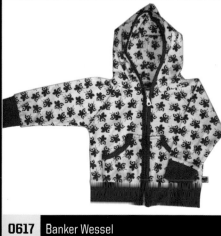

0617 Banker Wessel

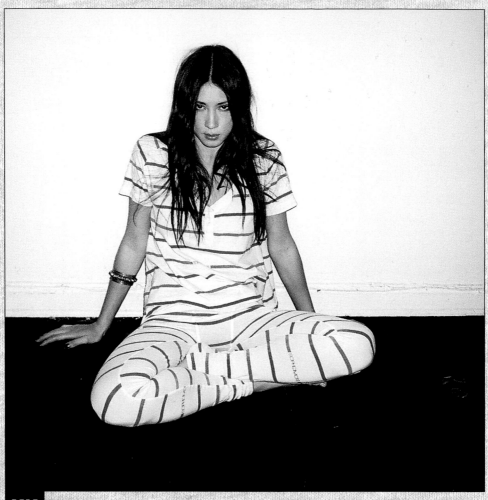

0618 Sophomore

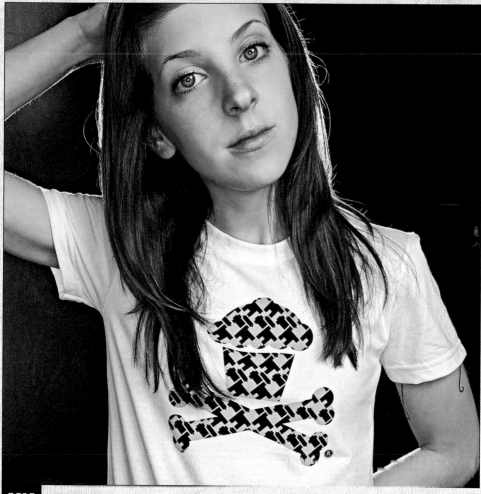

0619 Johnny Cupcakes

0620 Hybrid Design

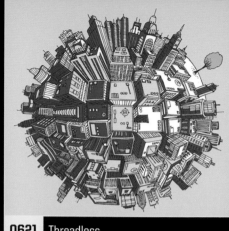

0621 Threadless

0622 Threadless

0623 DA Studios

0624 Threadless

0625 Threadless

0626 Print Brigade

0627 Threadless

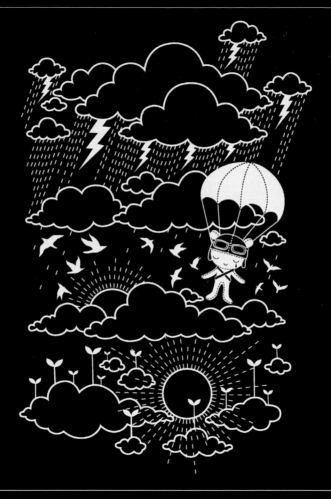

0629 Threadless

0630 Threadless

0631 Threadless

0632 Threadless

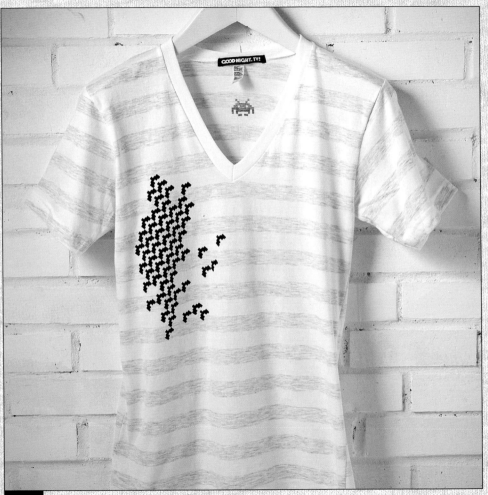

0633 Good Night TV

0634 Kristina Critchlow

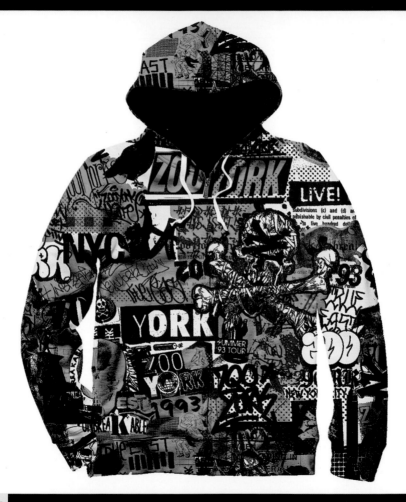

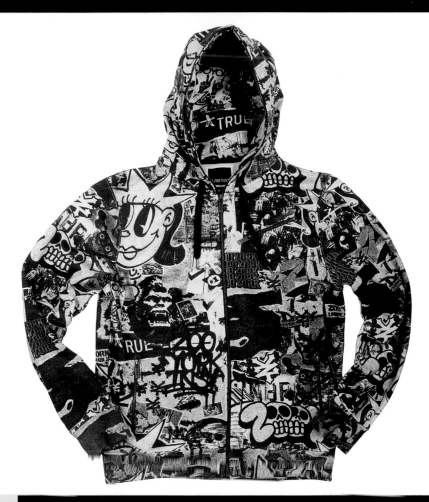

0636 Marc Ecko Enterprises

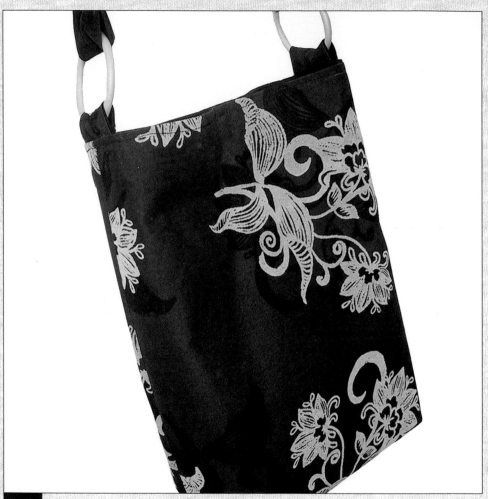

0637 Purses by Pants

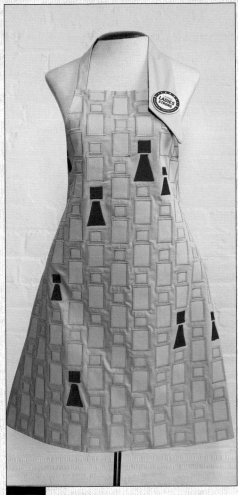

0638 Kimiyo Nakatsui

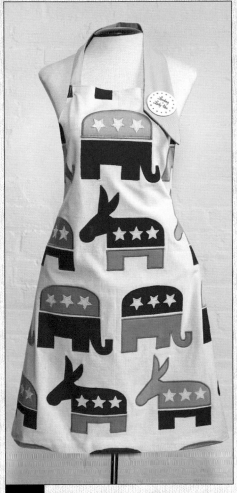

0639 Kimiyo Nakatsui

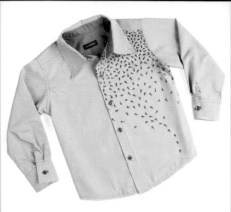

0640 Johnston Duffy

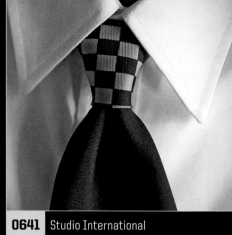

0641 Studio International

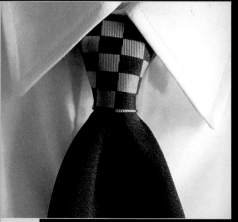

0642 Studio International

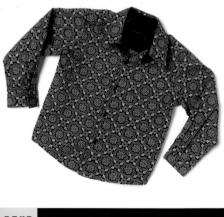

0643 Johnston Duffy

0644 Studio International

0645 Marc Ecko Enterprises

0646 Marc Ecko Enterprises

0647 Marc Ecko Enterprises

0648 Banker Wessel

0649 Banker Wessel

0650 Banker Wessel

0651 Banker Wessel

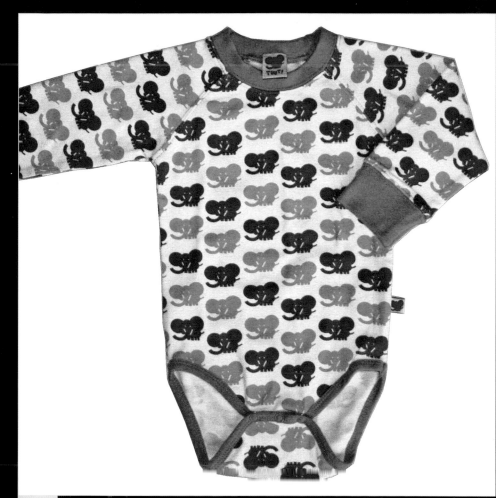

0652 Banker Wessel

0653 Banker Wessel

0654 Banker Wessel

0655 Banker Wessel

0656 Banker Wessel

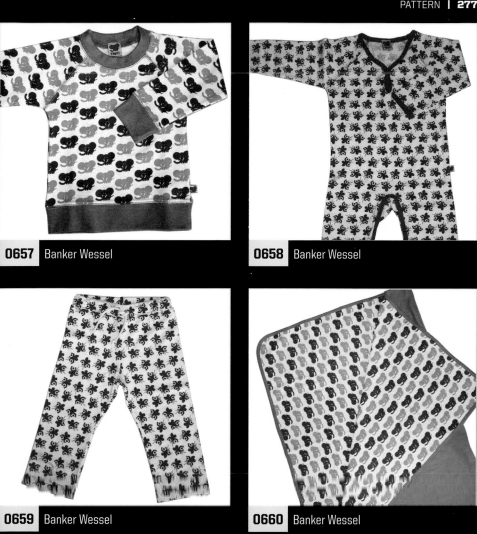

0657 Banker Wessel

0658 Banker Wessel

0659 Banker Wessel

0660 Banker Wessel

0661 Blue Q

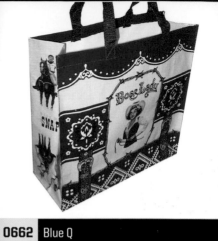

0662 Blue Q

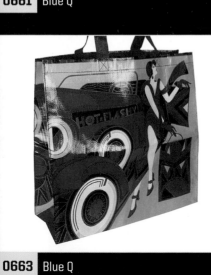

0663 Blue Q

0664 Blue Q

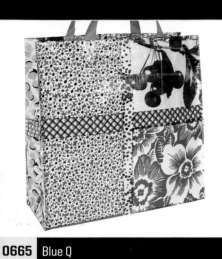

0665 Blue Q

0666 Blue Q

0667 Blue Q

0668 Blue Q

0669 Threadless

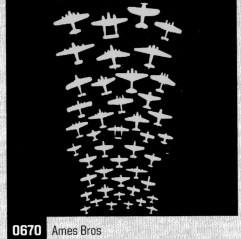

0670 Ames Bros

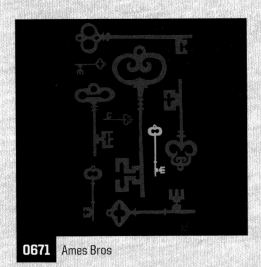

0671 Ames Bros

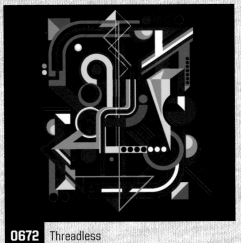

0672 Threadless

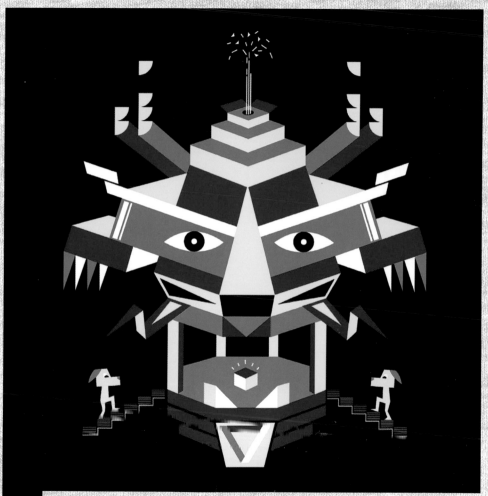

0673 Threadless

0674 Threadless

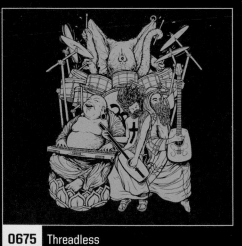

0675 Threadless

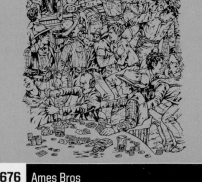

0676 Ames Bros

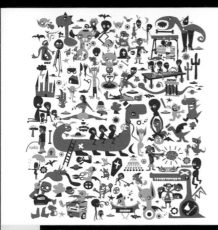

0677 Threadless

0678 Threadless

0679 Threadless

0680 Threadless

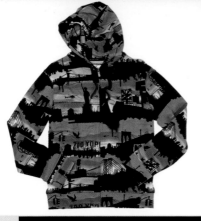

0681 Marc Ecko Enterprises

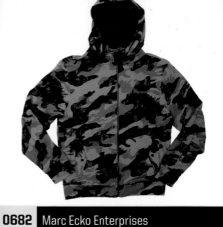

0682 Marc Ecko Enterprises

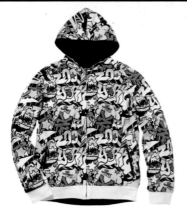

0683 Marc Ecko Enterprises

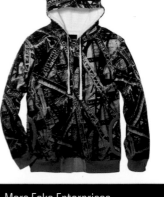

0684 Marc Ecko Enterprises

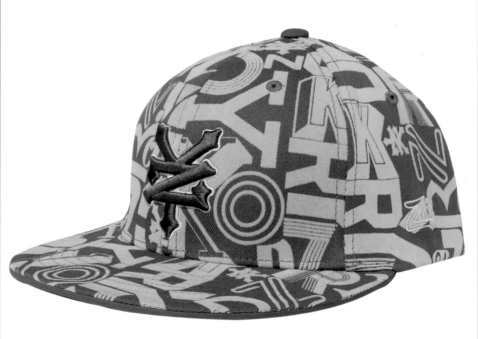

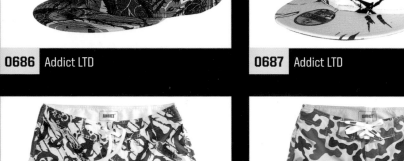

0686 Addict LTD

0687 Addict LTD

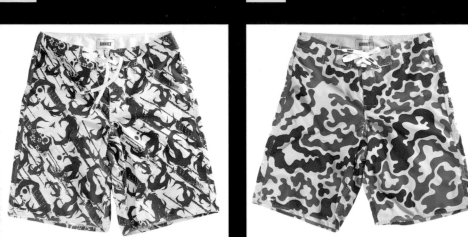

0688 Addict LTD

0689 Addict LTD

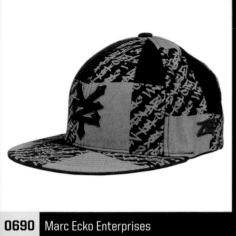

0690 Marc Ecko Enterprises

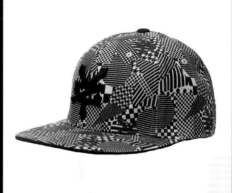

0691 Marc Ecko Enterprises

0692 Marc Ecko Enterprises

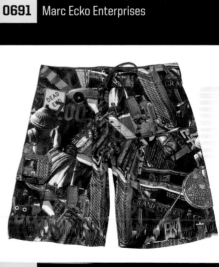

0693 Marc Ecko Enterprises

0694 Iskra Print Collective

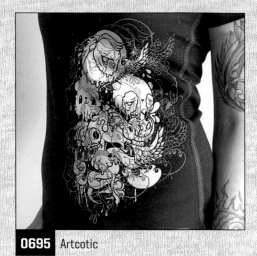

0695 Artcotic

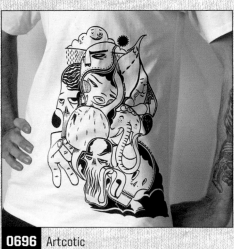

0696 Artcotic

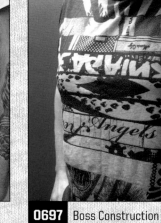

0697 Boss Construction

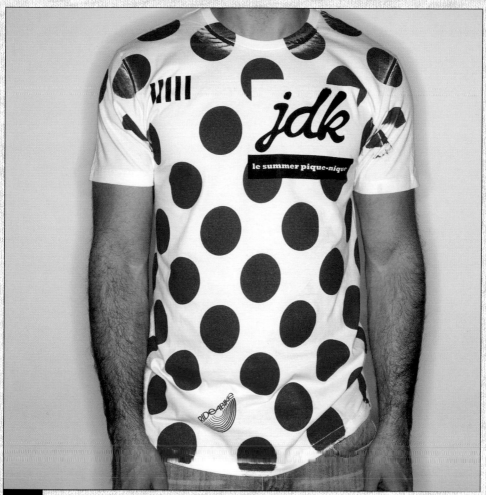

0698 Iskra Print Collective

0699 Jonathon Wye, LLC

0700 Jonathon Wye, LLC

0701 Jonathon Wye, LLC

0702 Jonathon Wye, LLC

0703 Jonathon Wye, LLC

0704 Jonathon Wye, LLC

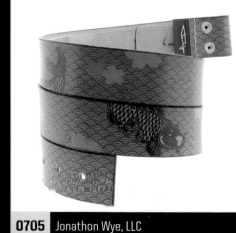

0705 Jonathon Wye, LLC

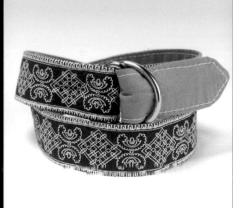

0706 Johnston Duffy

0707 Threadless

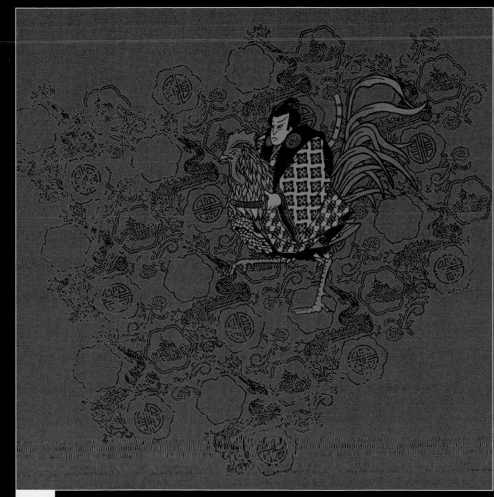

0708 Threadless

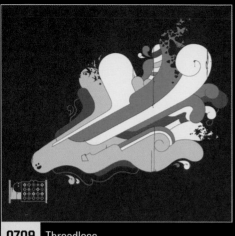

0709 Threadless

0710 Threadless

0711 Threadless

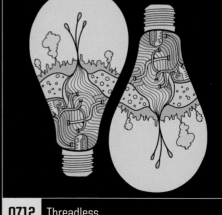

0712 Threadless

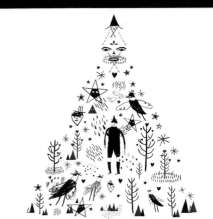

0713 Threadless

0714 Threadless

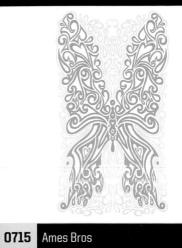

0715 Ames Bros

0716 Threadless

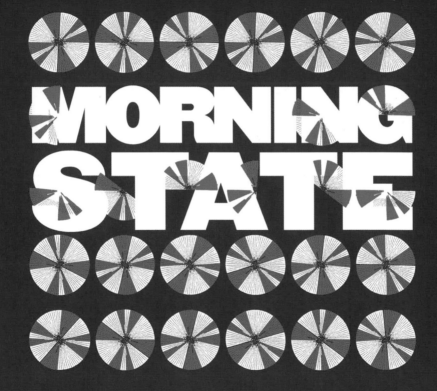

0717 Boss Construction

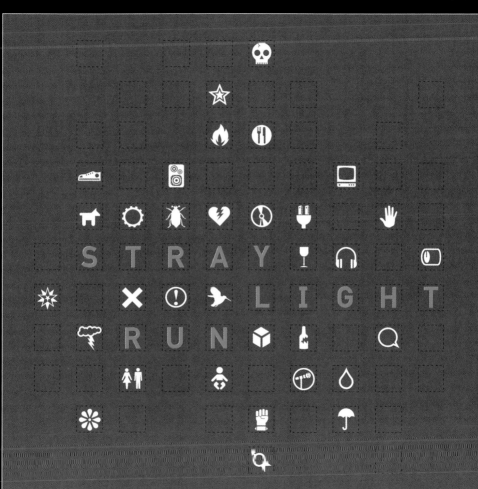

0718 Alphabet Arm Design

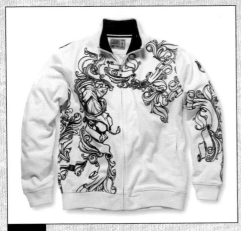

0719 Marc Ecko Enterprises

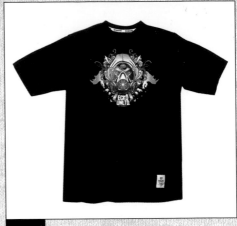

0720 Marc Ecko Enterprises

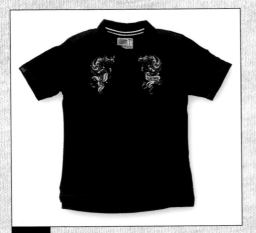

0721 Marc Ecko Enterprises

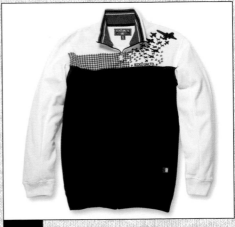

0722 Marc Ecko Enterprises

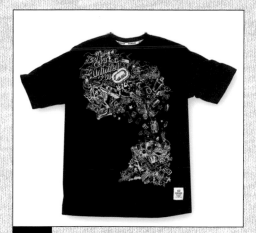

0723 Marc Ecko Enterprises

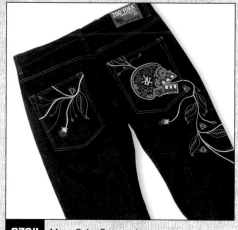

0724 Marc Ecko Enterprises

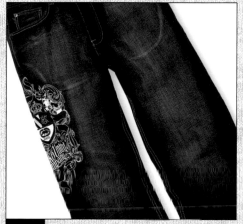

0725 Marc Ecko Enterprises

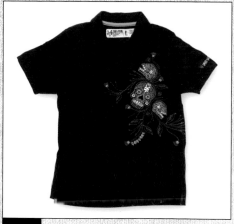

0726 Marc Ecko Enterprises

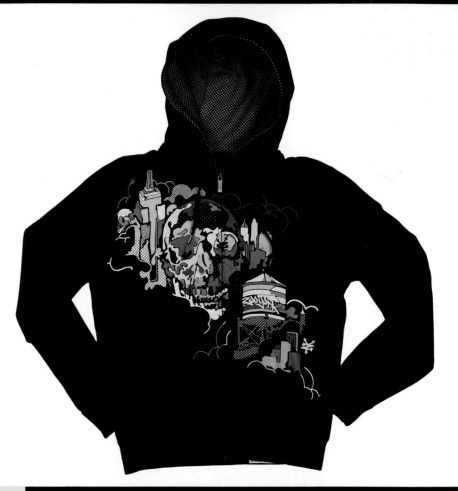

0728 Marc Ecko Enterprises

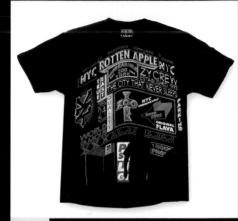

0729 Marc Ecko Enterprises

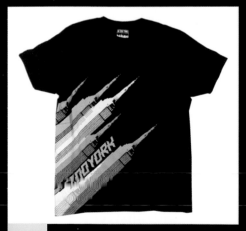

0730 Marc Ecko Enterprises

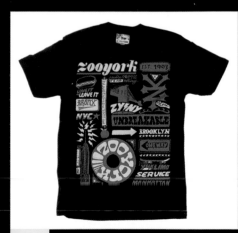

0731 Marc Ecko Enterprises

IISTVO LICA U SVEMIRU ARHEOLOŠKI MUZEJ U ZAGREBU GRADSK
EMIRU ARHEOLOŠKI MUZEJ U ZAGREBU GRADSKI MUZEJ VUKOVA
ŠKI MUZEJ U ZAGREBU GRADSKI MUZEJ VUKOVAR ŽELJKO PUŠIĆ
GREBU GRADSKI MUZEJ VUKOVAR ŽELJKO PUŠIĆ VUČEDOLSKA NIT
ŠKI MUZEJ VUKOVAR ŽELJKO PUŠIĆ VUČEDOLSKA NIT POBRATIMS
U VUKOVAR ŽELJKO PUŠIĆ VUČEDOLSKA NIT POBRATIMSTVO LICA U
R ŽELJKO PUŠIĆ VUČEDOLSKA NIT POBRATIMSTVO LICA U SVEMIRU
VUČEDOLSKA NIT POBRATIMSTVO LICA U SVEMIRU ARHEOLOŠKI MU
KA NIT POBRATIMSTVO LICA U SVEMIRU ARHEOLOŠKI MUZEJ U ZAG
MSTVO LICA U SVEMIRU ARHEOLOŠKI MUZEJ U ZAGREBU GRADSK
EMIRU ARHEOLOŠKI MUZEJ U ZAGREBU GRADSKI MUZEJ VUKOVA
ŠKI MUZEJ U ZAGREBU GRADSKI MUZEJ VUKOVAR ŽELJKO PUŠIĆ
GREBU GRADSKI MUZEJ VUKOVAR ŽELJKO PUŠIĆ VUČEDOLSKA NIT
ŠKI MUZEJ VUKOVAR ŽELJKO PUŠIĆ VUČEDOLSKA NIT POBRATIMS
U VUKOVAR ŽELJKO PUŠIĆ VUČEDOLSKA NIT POBRATIMSTVO LICA U

0734 Blue Q

0735 Blue Q

0736 Blue Q

0737 Blue Q

0738 Blue Q

0739 Blue Q

0740 Blue Q

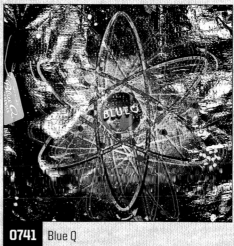

0741 Blue Q

0742 Johnny Cupcakes

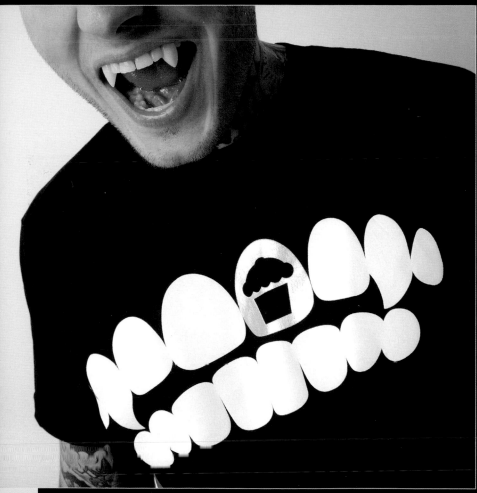

0743 Johnny Cupcakes

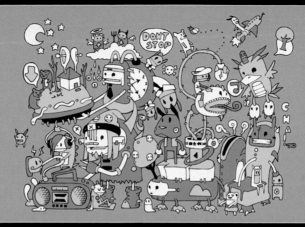

0745 Threadless

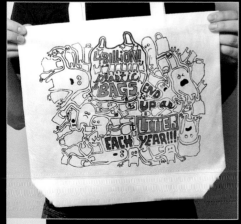

0746 Print Brigade

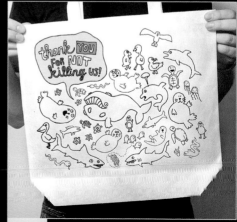

0747 Print Brigade

0748 Ames Bros

0749 Hybrid Design

0750 Hybrid Design

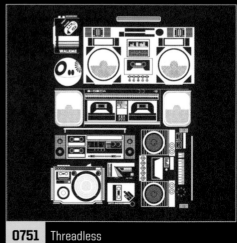

0751 Threadless

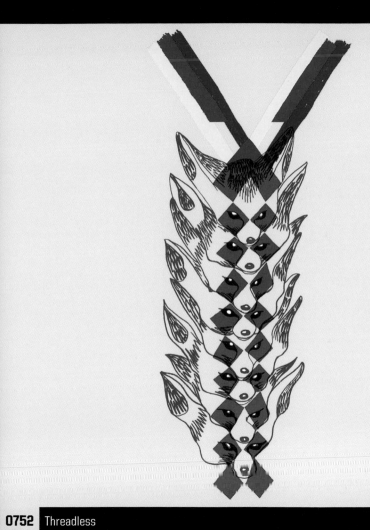

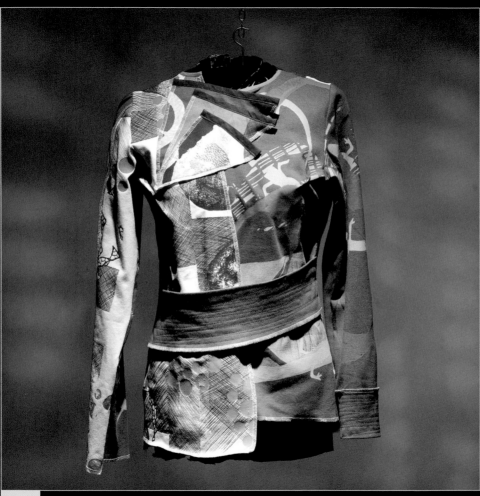

0753 Devetka

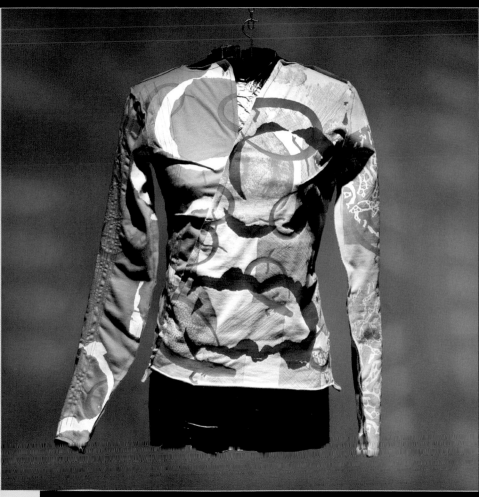

0754 Devetka

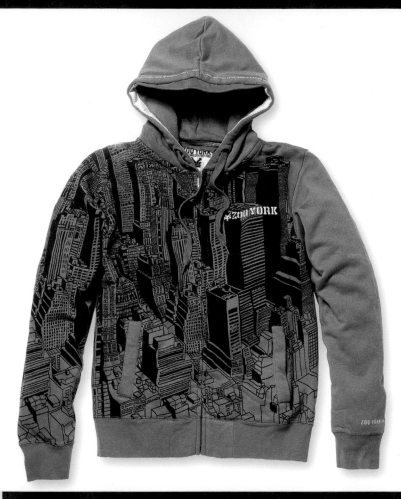

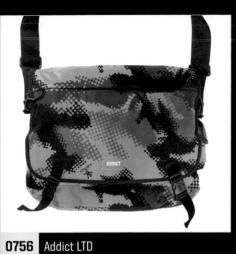

0756 Addict LTD

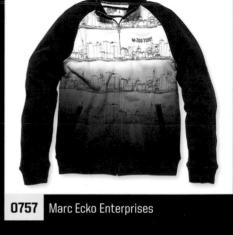

0757 Marc Ecko Enterprises

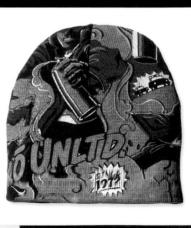

0758 Marc Ecko Enterprises

0759 Marc Ecko Enterprises

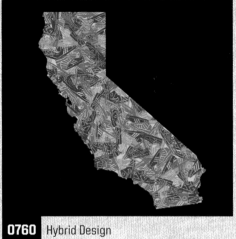

0760 Hybrid Design

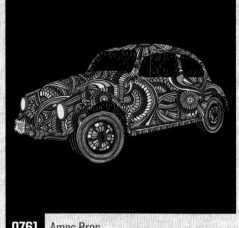

0761 Ames Bros

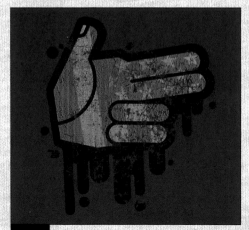

0762 Ames Bros

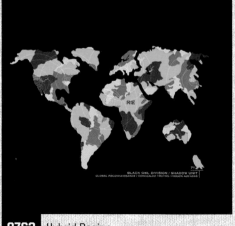

0763 Hybrid Design

0764 Banker Wessel

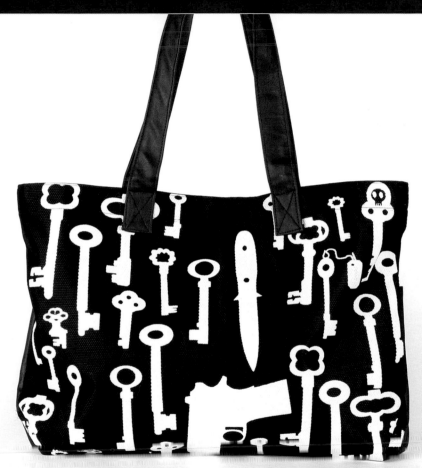

0766 De*Nada Design

05

Other

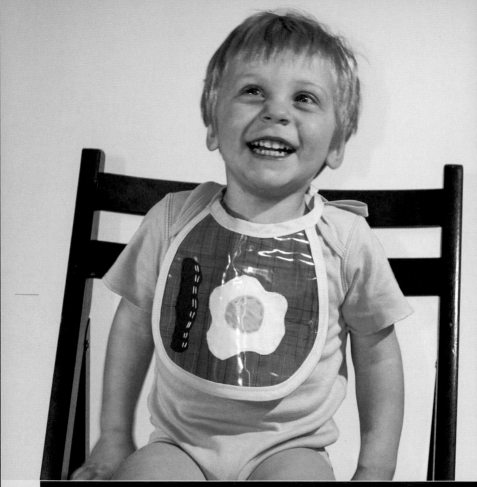

0768 Threadless

0769 Sheriff Peanut

0770 Sheriff Peanut

0771 xeroproject

0772 Alphabet Arm Design

0773 fuszion

0774 xeroproject

0775 Hero Design Studio

0776 Squidfire

0777 AdHouse Books

0778 Threadless

0779 Marc Ecko Enterprises

0780 DA Studios

0781 Ryan Goeller

0782 Ames Bros

0783 Ames Bros

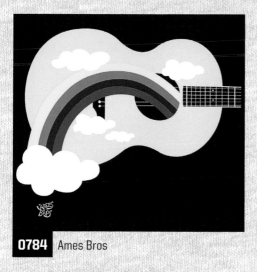

0784 Ames Bros

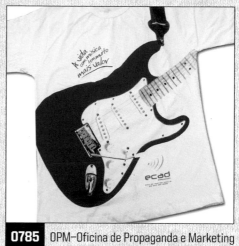

0785 OPM–Oficina de Propaganda e Marketing

0786 Hybrid Design

0787 Hybrid Design

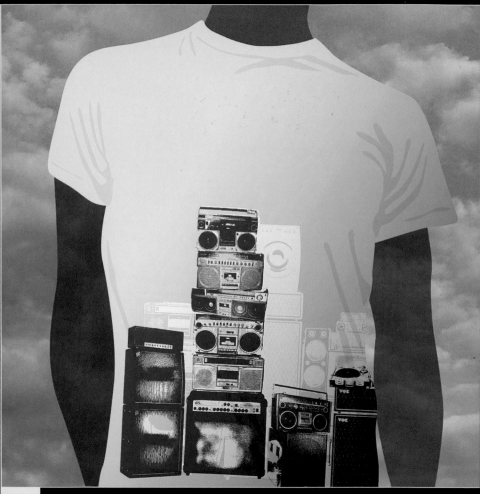

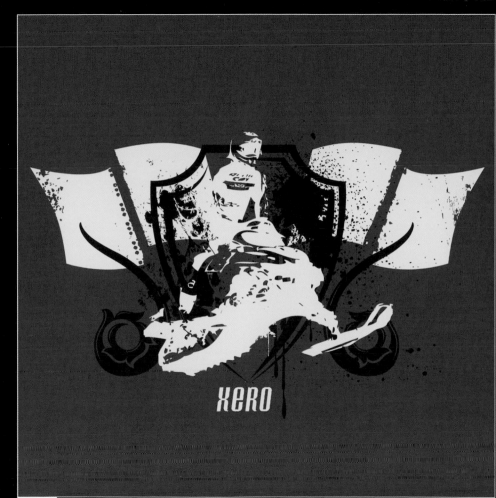

0789 xeroproject

0790 Ames Bros

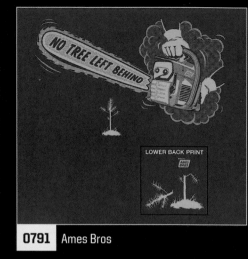

0791 Ames Bros

0792 Ames Bros

0793 Ames Bros

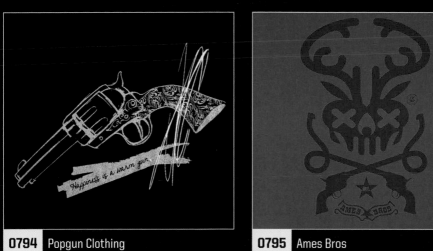

0794 Popgun Clothing

0795 Ames Bros

0796 Methane Studios, Inc

0797 Giant Robot

0798 Threadless

0799 Nodivision Design Syndicate

0800 Nodivision Design Syndicate

0801 Threadless

0802 Threadless

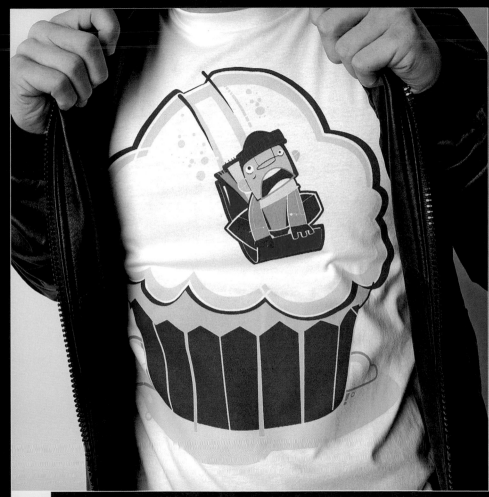

0804 Johnny Cupcakes

0805 Di Depux

0806 Crowded Teeth

0807 AdHouse Books

0808 Di Depux

0809 Di Depux

0810 De*Nada Design

0811 Jonathan Wye, LLC

0812 Studio International

0813 De*Nada Design

0814 LIES

0815 LIES

0816 LIES

0817 LIES

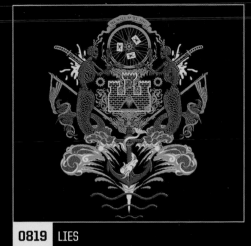

0819 LIES

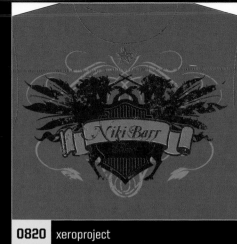

0820 xeroproject

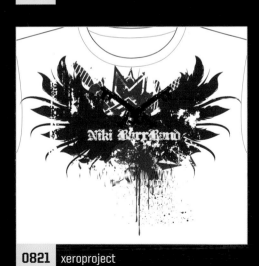

0821 xeroproject

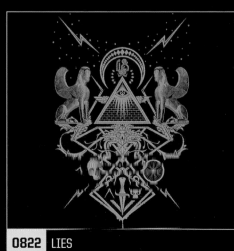

0822 LIES

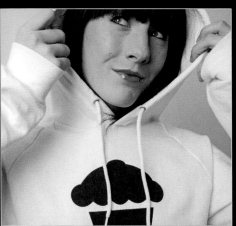

0823 Johnny Cupcakes

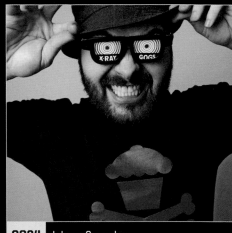

0824 Johnny Cupcakes

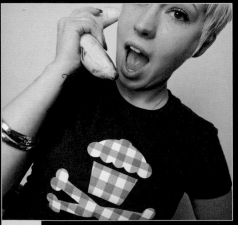

0825 Johnny Cupcakes

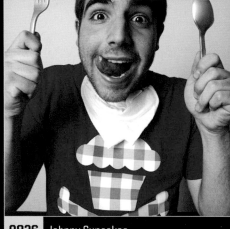

0826 Johnny Cupcakes

0827 Johnny Cupcakes

0828 Threadless

0829 Ames Bros

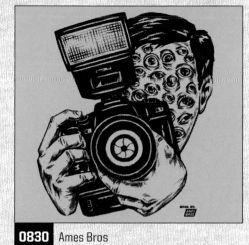

0830 Ames Bros

0831 El Jefe Design

0832 Alphabet Arm Design

AIR BOMB

PRE-FAB WARFARE

NO SNIFFING GLUE

R:E

0834 Hybrid Design

0835 Hybrid Design

0836 Hybrid Design

0837 Hybrid Design

0838 Hybrid Design

0839 Hybrid Design

0840 Hybrid Design

0841 Hybrid Design

0842 Hybrid Design

0843 Hybrid Design

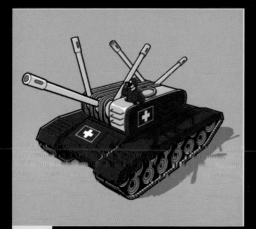

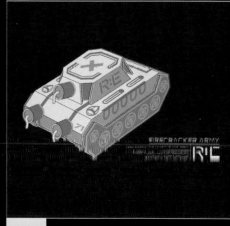

0844 Hybrid Design

0845 Hybrid Design

0846 Threadless

0847 Threadless

0848 The Faded Line Clothing Co.

0849 Sophomore

0850 Ames Bros

0851 Hybrid Design

0852 Crowded Teeth

0853 Ames Bros

0854 popidiot

0855 Kimiyo Nakatsui

0856 Marc Ecko Enterprises

0857 Johnston Duffy

0858 Johnston Duffy

0859 Marc Ecko Enterprises

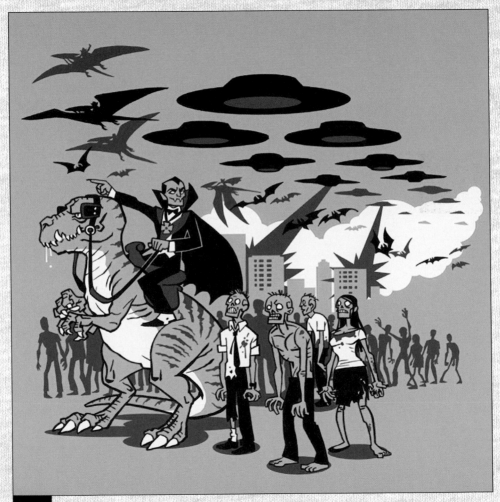

0860 Threadless

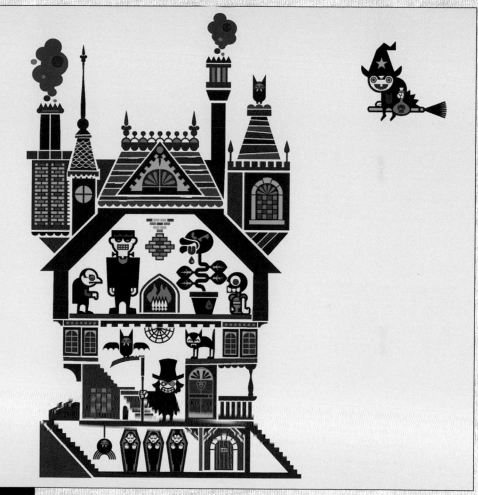

0861 Threadless

0862 Threadless

0863 Threadless

0864 Johnny Cupcakes

0865 Johnny Cupcakes

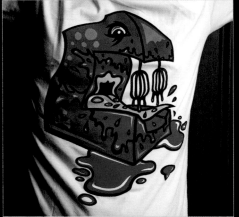

0866 Johnny Cupcakes

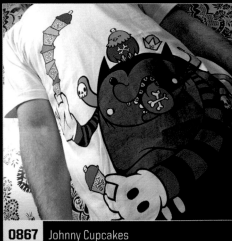

0867 Johnny Cupcakes

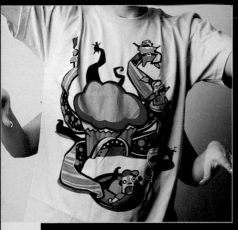

0868 Johnny Cupcakes

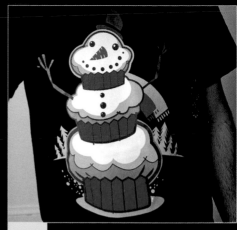

0869 Johnny Cupcakes

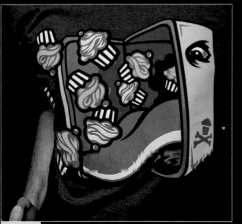

0870 Johnny Cupcakes

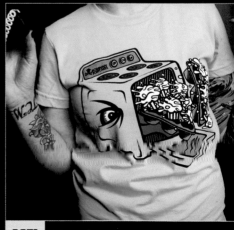

0871 Johnny Cupcakes

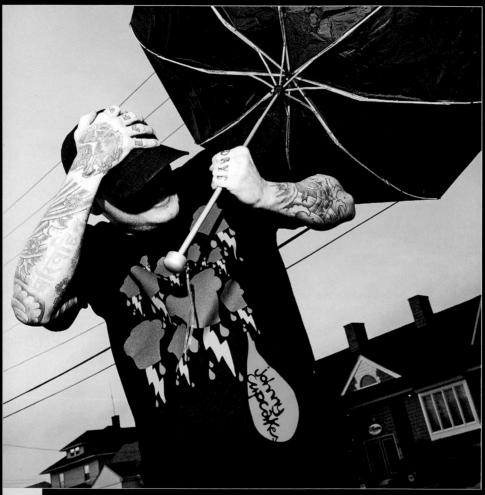

Johnny Cupcakes

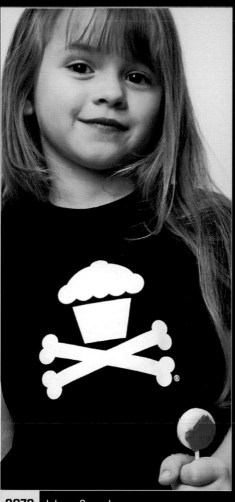

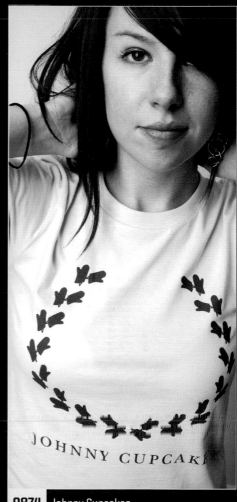

0873 Johnny Cupcakes

0874 Johnny Cupcakes

0876 Alphabet Arm Design

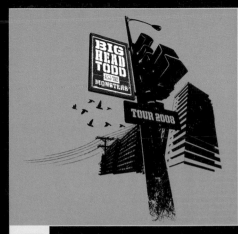

0877 Alphabet Arm Design

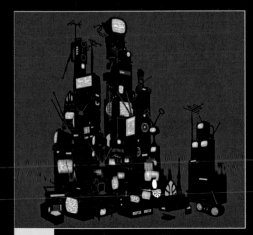

0878 Skinny Corp, LLC

0879 Ames Bros

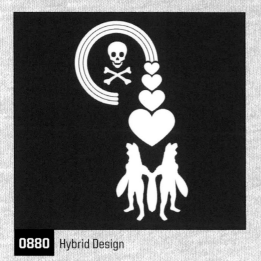

0880 Hybrid Design

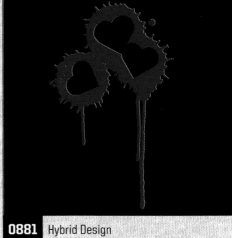

0881 Hybrid Design

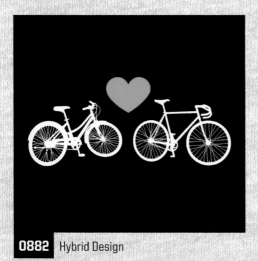

0882 Hybrid Design

0883 Hybrid Design

0884 Hybrid Design

0885 Hybrid Design

0886 Hybrid Design

0887 Hybrid Design

0888 Alphabet Arm Design

0889 Artcotic

0890 Hero Design Studio

0891 Good Night TV

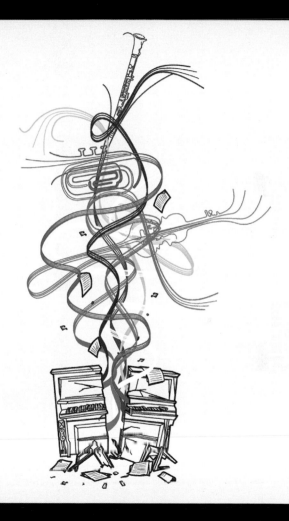

0893 Artcotic

0894 El Jefe Design

0895 El Jefe Design

0896 Hybrid Design

0897 Boss Construction

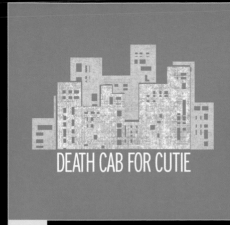

0898 Boss Construction

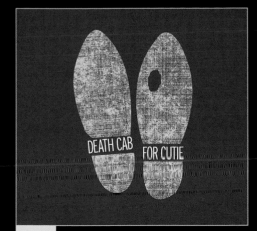

0899 Boss Construction

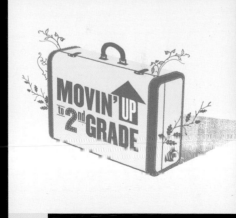

0900 Boss Construction

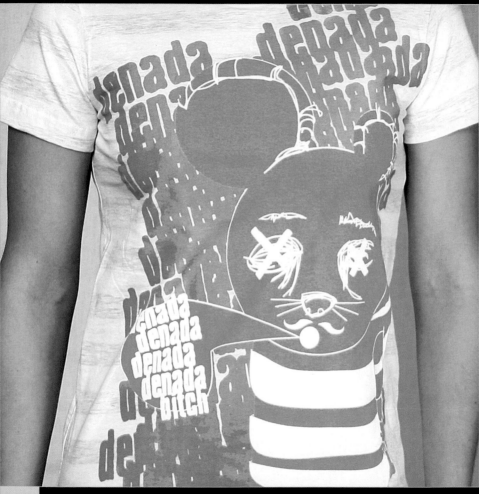

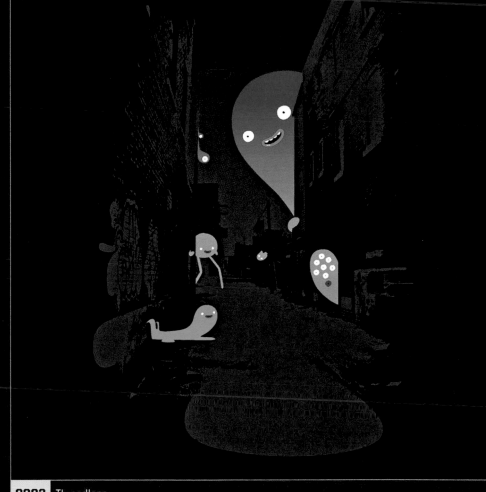

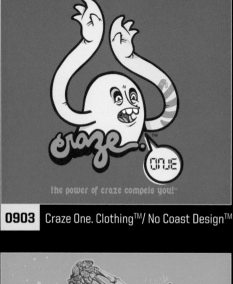

0903 Craze One. Clothing™/ No Coast Design™

0904 Craze One. Clothing™/ No Coast Design™

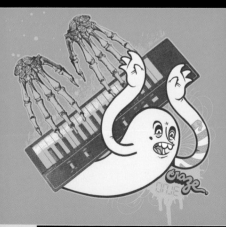

0905 Craze One. Clothing™/ No Coast Design™

0906 Good Night TV

0907 Crowded Teeth

0908 Artcotic

0909 Threadless

0910 Threadless

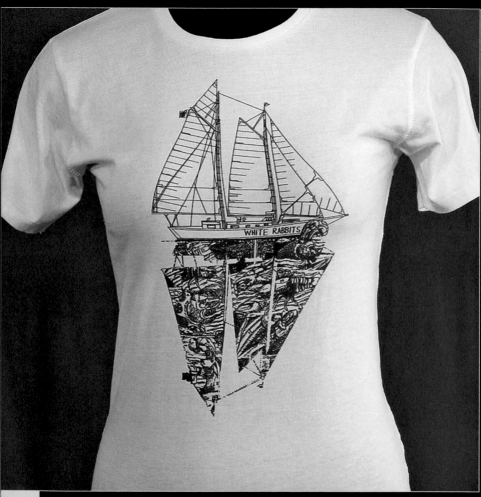

0912 Threadless

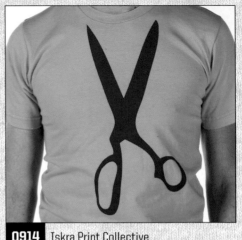

0913 Methane Studios, Inc

0914 Iskra Print Collective

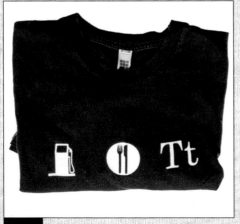

0915 Project M

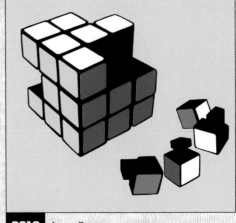

0916 Ames Bros

0917 Ames Bros

0918 Good Night TV

0919 Loyalty + Blood

0920 Firebelly Design

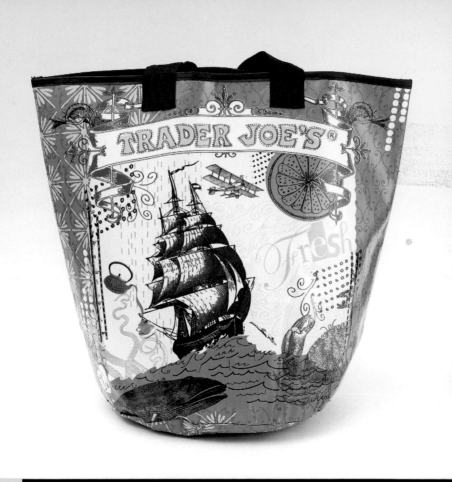

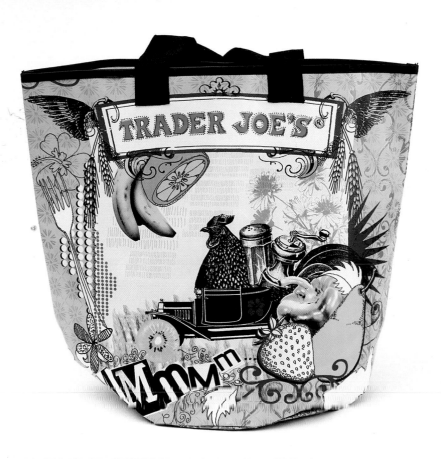

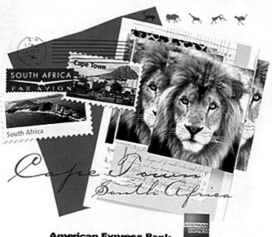

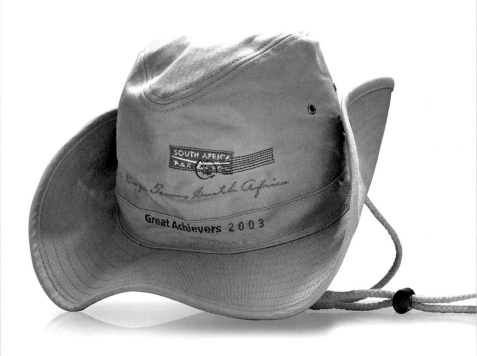

0925 Wing Chan Design, Inc.

0926 Wing Chan Design, Inc.

0927 Wing Chan Design, Inc.

0928 Wing Chan Design, Inc.

0929 Wing Chan Design, Inc.

0930 Wing Chan Design, Inc.

0931 Wing Chan Design, Inc.

0932 Wing Chan Design, Inc.

AdHouse
B O O K S
dotCOM

0933 AdHouse Books

0934 Threadless

0935 Marc Ecko Productions

0936 Firebelly Design

0937 Scrambled Eggz Productions

0938 Black Van Industries

0939 DA Studios

0940 Hive Creative

0941 De*Nada Design

0942 DA Studios

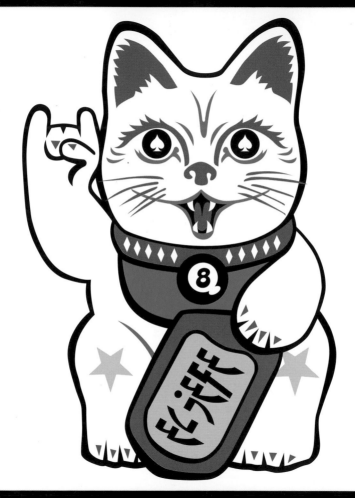

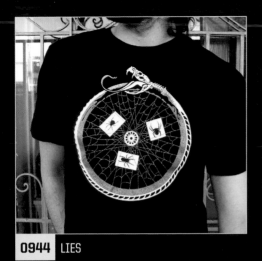

0944 LIES

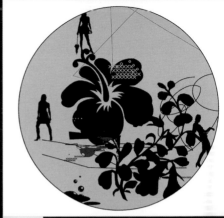

0945 Di Depux

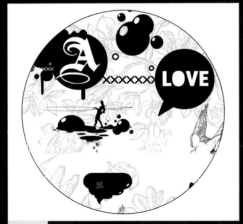

0946 Di Depux

0947 Alphabet Arm Design

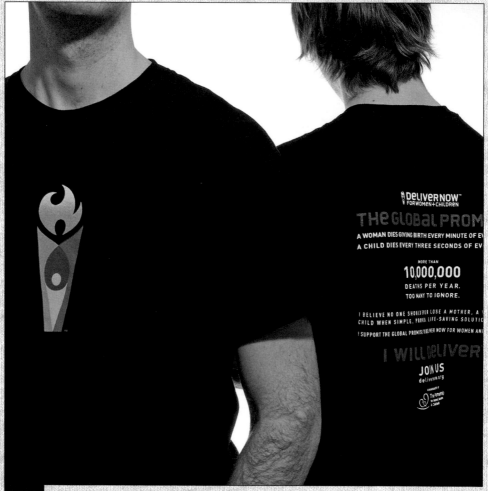

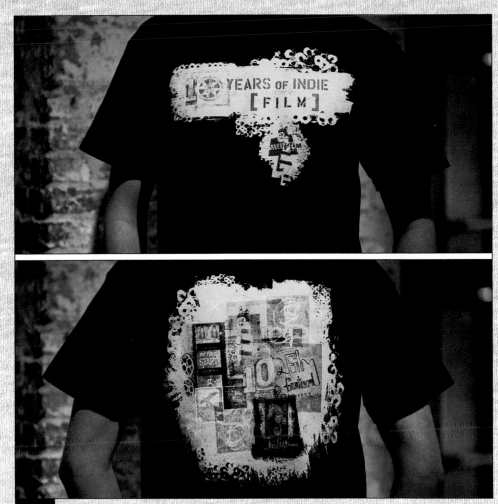

0949 Siquis

0950 Pappas MacDonnell, Inc.

0951 Johnston Duffy

0952 Johnston Duffy

0953 Studio International

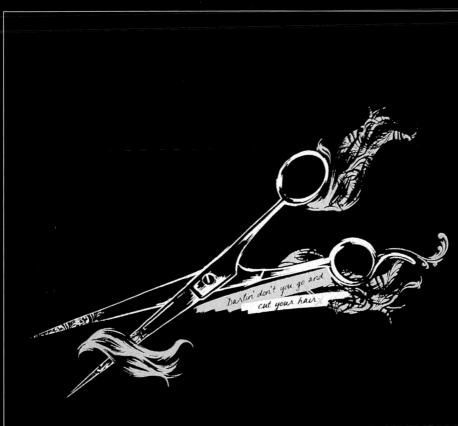

0954 Popgun Clothing

1-WHITE 2-SKY 3-CYAN 4-MIDNIGHT NAVY

0956 Hybrid Design

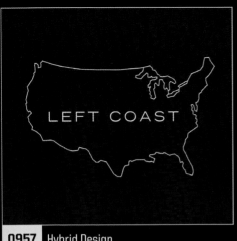

0957 Hybrid Design

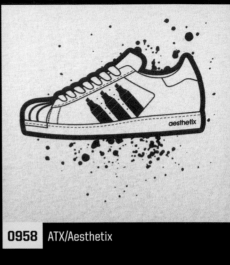

0958 ATX/Aesthetix

0959 OrangeYouGlad

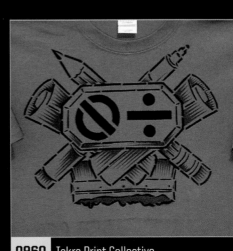

0960 Iskra Print Collective

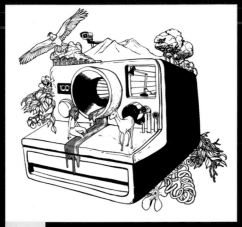

0961 Threadless

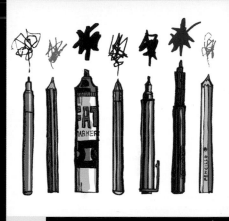

0962 Threadless

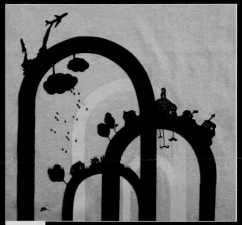

0963 Red Prairie Press

0964 Red Prairie Press

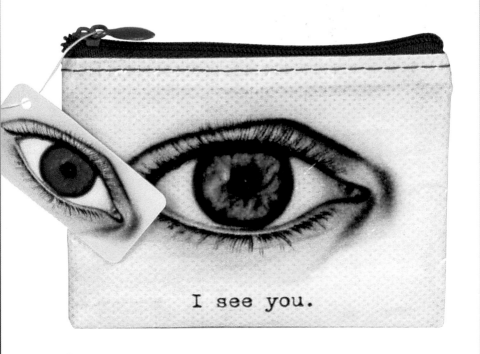

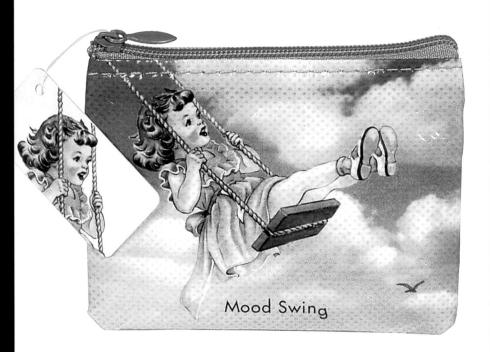

Mood Swing

0967 Blue Q

0968 Blue Q

0969 Blue Q

0970 Blue Q

0971 Blue Q

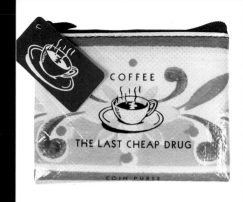

0972 Blue Q

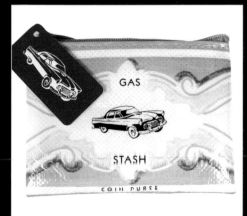

0973 Blue Q

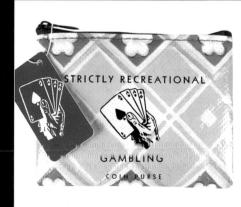

0974 Blue Q

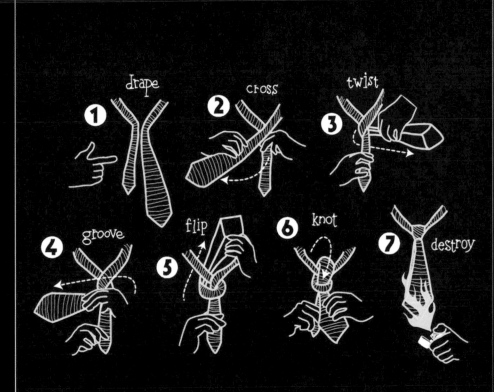

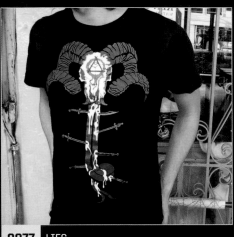

0977 LIES

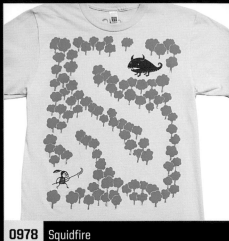

0978 Squidfire

0979 Gunnar Swanson Design Office

0980 Threadless

**Super Terrific
Animal Friendlies**

0984 Threadless

0985 Threadless

0986 Threadless

0987 Threadless

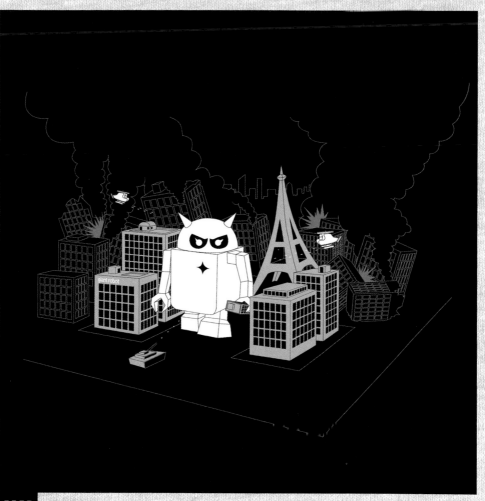

0988 Giant Robot

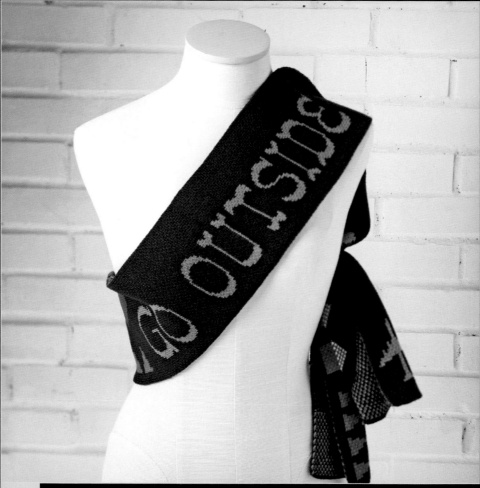

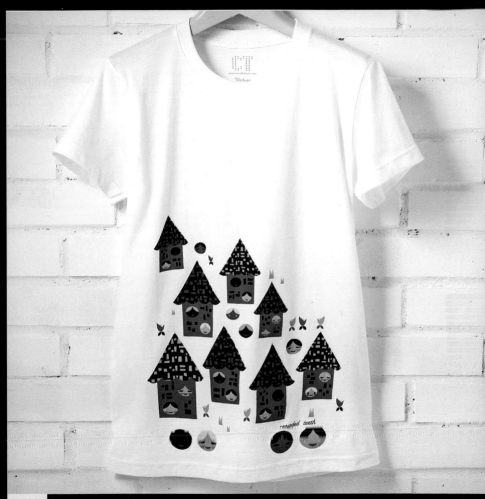

0990 Crowded Teeth

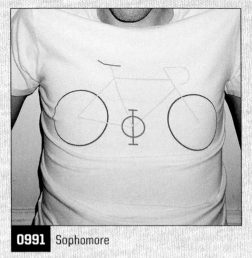

0991 Sophomore

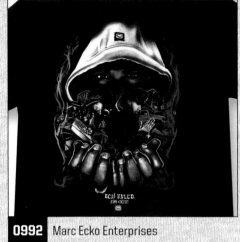

0992 Marc Ecko Enterprises

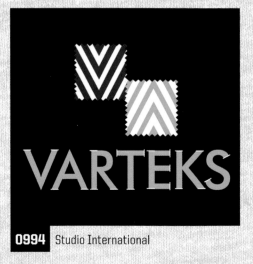

0993 Firebelly Design

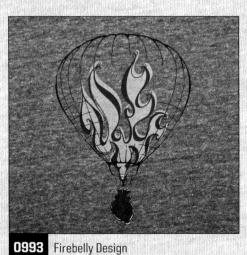

0994 Studio International

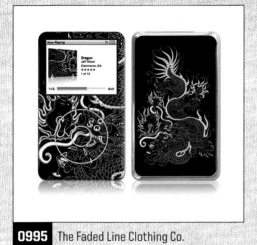

0995 The Faded Line Clothing Co.

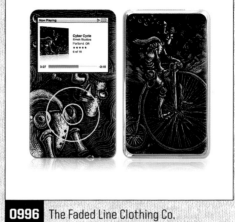

0996 The Faded Line Clothing Co.

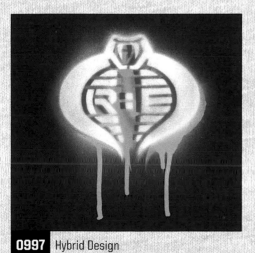

0997 Hybrid Design

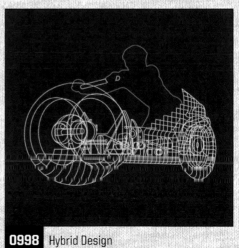

0998 Hybrid Design

1000 William Homan Design

ENDING NOTES
INDEX & AUTHOR

ADDICT LTD
Guy Stauber
Unit 2, Muira Ind. Est. William St.
Soton/Hants/SO14 5QH
UK
+44.23.8033.0344
guy@addict.co.uk
www.addict.co.uk
www.addictclothing.com

0058, 0598, 0599, 0600, 0601, 0686,
0687, 0688, 0689, 0756
ART DIRECTOR: Chris Carden-Jones
DESIGNER: Chris Carden-Jones
CLIENT: Addict

ADHOUSE BOOKS
Chris Pitzer
1224 Greycourt Ave.
Richmond, VA 23227
USA
804.262.7045
pitzer@adhousebooks.com
www.adhousebooks.com

0777, 0807, 0933
ART DIRECTOR: Chris Pitzer
DESIGNER: Doug Fraser
CLIENT: AdHouse Books

ALPHABET ARM DESIGN
Ryan Frease
500 Harrison Avenue
Boston, MA 02118
USA
617.451.9990
info@alphabetarm.com
www.alphabetarm.com

0073, 0075, 0078, 0132, 0135, 0136,
0207, 0292, 0327, 0331, 0366, 0379,
0380, 0381, 0382, 0400, 0401, 0407,
0408, 0409, 0410, 0411, 0430, 0440,
0531, 0539, 0540, 0543, 0584, 0718,
0772, 0832, 0876, 0877, 0888, 0947
ART DIRECTOR: Aaron Belyea
DESIGNER: Aaron Belyea
CLIENT: Alphabet Arm Design

AMES BROS
Barry Ament
2118 8th Ave.
Seattle, WA 98121
USA
206.516.3020
barry@amesbros.com
www.amesbros.com

0008, 0009, 0012, 0013, 0023, 0024,
0028, 0029, 0030, 0032, 0040, 0041,
0060, 0076, 0077, 0080, 0081, 0088,
0106, 0125, 0126, 0147, 0148, 0149,
0154, 0159, 0160, 0162, 0163, 0171,
0190, 0194, 0197, 0203, 0204, 0205,
0206, 0218, 0219, 0223, 0226, 0232,
0252, 0265, 0291, 0317, 0326, 0337,
0338, 0344, 0359, 0360, 0364, 0365,
0371, 0405, 0406, 0412, 0413, 0444,
0445, 0446, 0447, 0449, 0459, 0460,
0461, 0496, 0566, 0567, 0568, 0670,
0671, 0676, 0715, 0748, 0761, 0762,
0782, 0783, 0784, 0790, 0791, 0792,
0793, 0795, 0829, 0830, 0850, 0853,
0879, 0916, 0917
CLIENT: Ames Bros. Clothing

ARTCOTIC

Alex Lodermeier
alex@artcotic.com
www.artcotic.com

0007, 0010, 0089, 0090, 0091, 0092,
0093, 0094, 0099, 0101, 0112, 0114,
0170, 0279, 0315, 0318, 0322, 0695,
0696, 0889, 0893, 0908, 0911
ART DIRECTOR: Alex Lodermeier
CLIENT: Artcotic

ATX/AESTHETIX

Jeremy Thompson
P.O. Box 480093
Charlotte, NC 28269
USA
980.253.3410
jthompson@studioatx.com
www.sup3rfr3sh.com

0431, 0432, 0433, 0495, 0497, 0542,
0575, 0958
ART DIRECTOR: Jeremy Thompson
DESIGNER: Jeremy Thompson
CLIENT: SUP3RFR3SH

BANKER WESSEL

Jonas Banker
Skeppsbrun 10
SE-111 30 Stockholm
Sweden
+46.8.224631
info@bankerwessel.com
www.bankerwessel.com

0216, 0217, 0613, 0614, 0615, 0616,
0617, 0648, 0649, 0650, 0651, 0652,
0653, 0654, 0655, 0656, 0657, 0658,
0659, 0660, 0764
ART DIRECTOR: Ida Wessel, Jonas
Banker
DESIGNER: Ida Wessel, Jonas Banker
CLIENT: Banker Wessel

BLACK VAN INDUSTRIES

Arianne Gibbs
205 North San Mateo Ave.
Ventura, CA 93004
USA
805.217.5367
agibbs@blackvanindustries.com
www.blackvanindustries.com

0001, 0002, 0003, 0004, 0005, 0051,
0052, 0481, 0482, 0483, 0484, 0938
ART DIRECTOR: Damon Robinson
DESIGNER: Damon Robinson
CLIENT: Black Van Industries

BLUE Q

103 Hawtorne Avenue
Pittsfield, MA 01201
USA
800.321.7576
trevor@blueq.com
www.blueq.com

0062, 0063, 0066, 0240, 0269, 0662,
0663, 0968

0064, 0518, 0521, 0522, 0661
DESIGNER: Fiona Hewitt

0065
DESIGNER: Dragon

0067, 0068, 0069
DESIGNER: Misery Boutique

0236, 0237, 0238, 0239, 0270, 0271, 0272, 0273 , 0274, 0275, 0462, 0467, 0734, 0735, 0736, 0737, 0740, 0741, 0965, 0966, 0970, 0971, 0972, 0973, 0974
DESIGNER: Roy Fox

0241, 0268
DESIGNER: Catalina Estrada

0242
DESIGNER: Vinnie D'Angelo

0243, 0468
DESIGNER: Modern Dog

0339
DESIGNER: Michel Casarramona

0340
DESIGNER: Saelee Oh

0352, 0354, 0357, 0665, 0668
DESIGNER: Haley Johnson Design

0463, 0464, 0664, 0666
DESIGNER: Louise Fili

0465
DESIGNER: The Heads of State

0466, 0469, 0520, 0667
DESIGNER: Ray Fenwick

0738
DESIGNER: Charles Wilkin

0739
DESIGNER: Niki Amano

0967
DESIGNER: Team Macho

0969
DESIGNER: Cary Taxali

BOSS CONSTRUCTION
Andrew Vastagh
3927 Moss Rose Drive
Nashville, TN 37216
USA
615.975.1921
avastagh@gmail.com
www.bossconstruct.com

0199
ART DIRECTOR: Andrew Vastagh
DESIGNER: Andrew Vastagh
CLIENT: Arma Secreta

0296, 0898, 0899
ART DIRECTOR: Andrew Vastagh
DESIGNER: Andrew Vastagh
CLIENT: Death Cab for Cutie

0376
ART DIRECTOR: Andrew Vastagh
DESIGNER: Andrew Vastagh
CLIENT: Colour Revolt

0529, 0697
ART DIRECTOR: Andrew Vastagh
DESIGNER: Andrew Vastagh
CLIENT: Construct Clothing Co.

0717
ART DIRECTOR: Andrew Vastagh
DESIGNER: Andrew Vastagh
CLIENT: Morning State

0897
ART DIRECTOR: Andrew Vastagh
DESIGNER: Andrew Vastagh
CLIENT: Goner Records

0900
ART DIRECTOR: Andrew Vastagh
DESIGNER: Andrew Vastagh
CLIENT: Lausanne Collegiate School

CHRISTAINSEN : CREATIVE
Tricia Christiansen
511 2nd St., Suite 206
Hudson, WI 54016
USA
715.381.8480
tricia@christiansencreative.com
www.christiansencreative.com

0134, 0441, 0490, 0512, 0515, 0524, 0537, 0544
ART DIRECTOR: Tricia Christiansen
DESIGNER: Tricia Christiansen
CLIENT: The Purple Tree

CLAY MCINTOSH CREATIVE
Clay McIntosh
4530 S. Sheridan, Suite 202
Tulsa, OK 74145
USA
918.591.3070
clay@claymcintosh.com
www.claymcintosh.com

0508, 0517
ART DIRECTOR: Clay McIntosh
DESIGNER: Clay McIntosh
CLIENT: OK Music Fanatics

**CRAZE ONE. CLOTHING™/
NO COAST DESIGN™**
Adam White
3800 North 22nd Street
Lincoln, NE 68521
USA
402.570.4673
adam@crazeone.com
www.crazeone.com

0349, 0373, 0498, 0903, 0904, 0905
ART DIRECTOR: Adam White
DESIGNER: Adam White
CLIENT: Craze One. Clothing™

CROWDED TEETH
Michelle Romo
4416 Camero Ave.
Los Angeles, CA 90027
USA
818.458.6558
michelle@crowdedteeth.com
www.crowdedteeth.com

0266, 0324, 0361, 0806, 0852, 0907, 0989, 0990
ART DIRECTOR: Michelle Romo
DESIGNER: Michelle Romo
CLIENT: Go Outside

DA STUDIOS
Deanna Alcorn
690 Fifth Street, #213
San Francisco, CA 94107
USA
415.348.8809
Deanna@dastudios.com
www.dastudios.com

0042, 0043, 0044, 0045, 0115, 0225, 0323, 0491, 0492, 0623, 0780, 0939, 0942
DESIGNER: Deanna Alcorn
CLIENT: Bravado International Group

DE*NADA DESIGN
Virginia Arrisueño
1549 3rd St. NW
Washington, D.C. 20001
USA
202.361.6507
info@denadadesign.com
www.denadadesign.com

0049, 0178, 0523, 0766, 0810, 0813, 0901, 0941

DEVETKA
Tanja Devetak
Gornji TRG 1
Ljubljana 1000
Slovenia
00.386.1.5195072
tanja.devetak@siol.net

0753, 0754
ART DIRECTOR: Tanja Devetak
DESIGNER: Tanja Devetak
CLIENT: Devetka

DI DEPUX
Despina Bournele
Meg. Alexandrou 18
Dafni-Athens 172 35
Greece
+30.210.9755850
info@depux.com
www.depux.com

0021, 0298, 0805, 0808, 0809, 0945, 0946
ART DIRECTOR: Despina Bournele
DESIGNER: Despina Bournele
CLIENT: Di Depux-Despina Bournele

EBD
Lisa Wright
2500 Walnut St., #401
Denver, CO 80205
USA
303.830.8323
lisa@ebd.com
www.ebd.com

0342, 0486, 0514
ART DIRECTOR: Ellen Bruss
DESIGNER: Jorge Lamora
CLIENT: The Lab Art + Ideas

EL JEFE DESIGN
Jeffrey Everett
7623 Moccasin Lane
Derwood, MD 20855
USA
301.461.6142
info@eljefedesign.com
www.eljefedesign.com

0083, 0151, 0152, 0153, 0277, 0532, 0534, 0565, 0579, 0582, 0831, 0894, 0895, 0943
ART DIRECTOR: Jeffrey Everett
CLIENT: El Jefe Design

FIREBELLY DESIGN
Dawn Hancock
2701 W. Thomas, 2nd Fl
Chicago, IL 60622
USA
773.489.3200
info@firebellydesign.com
www.firebellydesign.com

0348, 0419, 0920, 0936, 0993
ART DIRECTOR: Dawn Hancock
DESIGNER: Travis Barteaux
CLIENT: Firebelly Design

FULLBLASTINC.COM
N. Todd Skiles
107 SE Washington St., #255
Portland, OR 97214
USA
503.227.2002
design@fullblastinc.com
www.fullblastinc.com

0210, 0211
ART DIRECTOR: N. Todd Skiles
DESIGNER: N. Todd Skiles
Illustrator: Eric Sappington
CLIENT: The Country Cat
Restaurant + Bar

FUSZION
John Foster
901 Prince Street
Alexandria, VA 22314
USA
703.548.8080
john@fuszion.com
www.fuszion.com

0164
DESIGNER: John Foster
CLIENT: John Guilt

0208
ART DIRECTOR:
DESIGNER: John Foster
CLIENT: The Carribean

0573
ART DIRECTOR:
DESIGNER: John Foster
CLIENT: Fulton Lights

0574
ART DIRECTOR:
DESIGNER: John Foster
CLIENT: Beauty Pill

0773
DESIGNER: John Foster
CLIENT: Roofwalkers

GEYRHALTER DESIGN
Abbey Park
2525 Main St., Suite 205
Santa Monica, CA 90405
USA
310.392.7615
abigail@geyrhalter.com
www.geyrhalter.com

0282, 0458
ART DIRECTOR: Fabian Geyrhalter
DESIGNER: Fabian Geyrhalter
CLIENT: Geyrhalter Design

GIANT ROBOT
Eric Nakamura
P.O. Box 642053
Los Angeles, CA 90064
USA
310.479.7311
eric@giantrobot.com
www.giantrobot.com

0174, 0193, 0562, 0563, 0797, 0888
ART DIRECTOR: Erick Nakamura
DESIGNER: Eric Nakamura
CLIENT: Giant Robot

GIORGIO DAVANZO DESIGN
Giorgio Davanzo
501 Roy Street #209
Seattle, WA 98109
USA
206.328.5031
giorgio@davanzodesign.com
www.davanzodesign.com

0420
ART DIRECTOR:
DESIGNER: Giorgio Davanzo
CLIENT: Giorgio Davanzo Design

GO WELSH
Craig Welsh
987 Mill Mar Road
Lancaster, PA 17601
USA
717.898.9000
info@gowelsh.com
www.gowelsh.com

0215, 0227, 0234, 0235, 0244, 0245,
0246, 0247, 0307, 0308, 0438
ART DIRECTOR: Craig Welsh
DESIGNER: Mike Gilbert
CLIENT: Blurt

GOOD NIGHT TV
Antonio Garcia
1400 W. Devon #322
Chicago, IL 60660
USA
312.238.8673
info@goodnighttv.com
www.goodnighttv.com

0056, 0181, 0233, 0283, 0353, 0434,
0435, 0436, 0437, 0633, 0765, 0891,
0906, 0918
ART DIRECTOR: The Team
CLIENT: Good Night TV

**GUNNAR SWANSON
DESIGN OFFICE**
Gunnar Swanson
1901 East 6th Street
Greenville, NC 27858
USA
252.258.7006
gunnar@gunnarswanson.com
www.gunnarswanson.com

0979
ART DIRECTOR: Gunnar Swanson
DESIGNER: Gunnar Swanson
CLIENT: EC Velo Club

HERO DESIGN STUDIO
Ryan Besch
93 Allen Street
Buffalo, NY 14202
USA
716.858.HERO
hero.design@mac.com
www.heroandsound.com

0276, 0301, 0302, 0320, 0335, 0403,
0775, 0890
ART DIRECTOR: Mark Brickey
DESIGNER: Ryan Besch
CLIENT: ear X-tacy Records

HIVE CREATIVE
Cade Bond
20A MacQuarle St.
Pramran/Victoria/3181
Australia
+613.9510.9744
cade@hive.com.au
www.hive.com.au

0022, 0053, 0585, 0586, 0587, 0588, 0788, 0940
ART DIRECTOR: Wayne Murphy
DESIGNER: Clair Dekker, Anne Hain, Craig Stapely
CLIENT: Politix

HYBRID DESIGN
Suzi Nuti
540 Delancey St., #303
San Francisco, CA 94107
USA
415.227.4700
suzi@hybrid-design.com
www.hybrid-design.com

0011, 0014, 0015, 0016, 0017, 0018, 0025, 0026, 0084, 0102, 0150, 0182, 0183, 0187, 0189, 0196, 0250, 0251, 0253, 0256, 0258, 0259, 0260, 0261, 0310, 0311, 0448, 0451, 0493, 0494, 0558, 0559, 0560, 0561, 0564, 0620, 0749, 0750, 0760, 0763, 0786, 0787, 0833, 0834, 0835, 0836, 0837, 0838, 0839, 0840, 0841, 0842, 0843, 0845, 0851, 0880, 0881, 0882, 0883, 0884, 0885, 0886, 0887, 0896, 0956, 0957, 0983, 0997, 0998
ART DIRECTOR: Dora Drimalas
DESIGNER: Dora Drimalas
CLIENT: Upper Playground

INNOVATIVE INTERFACES
Dean Hunsaker
5850 Shellmound Way
Emeryville, CA 94608
USA
510.655.6200
Jhunsaker@iii.com
www.iii.com

0402, 0050
ART DIRECTOR: Michael Jager
DESIGNER: Allison Ross
CLIENT:

ISKRA PRINT COLLECTIVE
Matthew Stevens
47 Maple St.
Burlington, VT 05401
USA
802.864.5884
hello@iskraprint.com
www.iskraprint.com

0095
ART DIRECTOR: Michael Jager
DESIGNER: Tyler Stout

0137
ART DIRECTOR: Michael Jager
DESIGNER: Allison Ross

0200, 0485
ART DIRECTOR: Michael Jager
DESIGNER: Leo Listi, Matthew Stevens

0487, 0489, 0536, 0698, 0060
ART DIRECTOR: Michael Jager

0488
ART DIRECTOR: Michael Jager
DESIGNER: Steve Cousins

0513, 0694
ART DIRECTOR: Michael Jager
DESIGNER: Malcom Buick

0914
ART DIRECTOR: Michael Jager
DESIGNER: Matthew Stevens

JOHNNY CUPCAKES

Johnny Earle
279 Newbury Street
Boston, MA 02116
USA
866.606.CAKE
info@johnnycupcakes.com
www.johnnycupcakes.com

0047, 0048, 0133, 0138, 0139, 0140,
0141, 0142, 0158, 0332, 0345, 0439,
0547, 0619, 0742, 0743, 0803, 0804,
0823, 0824, 0825, 0826, 0827, 0864,
0865, 0866, 0867, 0868, 0869, 0870,
0871, 0872, 0873, 0874, 0875

JOHNSTON DUFFY

Martin Duffy
803 S. 4th Street, First Floor
Philadelphia, PA 19147
USA
215.389.2888
martin@johnstonduffy.com
www.jonstonduffy.com

0293, 0294, 0525, 0526, 0527, 0535,
0640, 0643, 0706, 0857, 0858, 0951,
0952
ART DIRECTOR: Martin Duffy
DESIGNER: Andy Evans, Martin Duffy
CLIENT: Wonderboy Clothing

JONATHON WYE, LLC

Jonathon Wye
723 Independence Ave. SE
Washington, D.C. 20003
USA
202.368.4996
jonwye@jonwye.com
www.jonwye.com

0054, 0179, 0231, 0699, 0700, 0701,
0702, 0703, 0704, 0705, 0811
DESIGNER: Jonathon Wye

KIMIYO NAKATSUI

Kimio Nakatsui
31-34 30th St.
Long Island City, NY 11106
USA
646.867.5171
kimiyo.design@gmail.com

0533, 0638, 0639, 0855

KRISTINA CRITCHLOW

Kristina Critchlow
84 Forsyth St. #3R
New York, NY 10002
USA
203.219.5138
kcritchlow@kristonica.com
www.kristonica.com

0593, 0594, 0595, 0596, 0597, 0634

LEIA BELL POSTERS & FINE ART

Leia Bell
221 East Broadway
Salt Lake City, UT 84101
USA
801.634.7724
goprintgo@yahoo.com
www.leiabell.com

0248, 0297, 0333
DESIGNER: Leia Bell
CLIENT: leiabell.com promo

LIES

Caleb Kozlowski
65 Hill St., Suite D
San Francisco, CA 94110
USA
415.694.9461
info@everybodylies.net
www.everybodylies.net

0035, 0814, 0815, 0816, 0817, 0819,
0822, 0944, 0977
ART DIRECTOR: Caleb Kozlowski
DESIGNER: Caleb Kozlowski
CLIENT: LIES

LOYALTY + BLOOD

David Denosowicz, Maggie Doyle
209 Jackson Street, #1
Brooklin, NY 11211
USA
718.809.1732
loyaltyandblood@gmail.com
www.loyaltyandblood.com

0122, 0744, 0919
DESIGNER: Loyalty + Blood

LUCKY BUNNY VISUAL COMMUNICATIONS

Rich DeSimone
84 Fountain Street, Suite 306
Pawtucket, RI 02860
USA
info@luckybunny.net
www.luckybunny.net

0212, 0213, 0285, 0336, 0530
ART DIRECTOR: Rich DeSimone

MARC ECKO ENTERPRISES

David Smith
40 West 23rd Street
New York, NY 10010
USA
917.262.1237
davids@ecko.com

0104, 0113, 0180, 0295, 0392, 0393,
0394, 0395, 0396, 0397, 0398, 0399,
0414, 0415, 0416, 0417, 0418, 0421,
0422, 0423, 0424, 0425, 0426, 0427,
0428, 0470, 0471, 0472, 0473, 0474,
0475, 0476, 0477, 0478, 0479, 0503,
0504, 0505, 0506, 0507, 0602, 0605,
0606, 0607, 0608, 0609, 0610, 0611,
0612, 0635, 0636, 0645, 0646, 0647,
0679, 0680, 0681, 0682, 0683, 0684,
0685, 0690, 0693, 0719, 0720, 0721,
0722, 0723, 0724, 0725, 0726, 0727,
0728, 0729, 0730, 0731, 0755, 0757,
0758, 0759, 0779, 0856, 0859, 0935,
0992
DESIGNER: Marc Ecko Enterprises

METHANE STUDIOS, INC.
Mark McDevitt
158 Tuckahoe Path
Sharpsburg, GA 30277
USA
404.226.6744
mark@methanestudios.com
www.methanestudios.com

0038, 0039, 0074, 0143, 0166, 0188, 0230, 0346, 0367, 0429, 0796, 0913
ART DIRECTOR: Robert Lee, Mark McDevitt
DESIGNER: Robert Lee, Mark McDevitt
CLIENT: Methane

NASSAR DESIGN
Nelinda Nassar
11 Park Street
Brookline, MA 02446
USA
617.264.2862
n.nassar@verizon.net
www.nassardesign.com

0569, 0576
ART DIRECTOR: Nelinda Nassar
DESIGNER: Nelinda Nassar
CLIENT: TSA The Stubbins Associates

NATEDUVAL.COM
Nate Duval
93 S. Maple St., Apt. 7
Westfield, MA 01085
USA
315.263.6770
nate@nateduval.com
www.nateduval.com

0120, 0121, 0123, 0165, 0328, 0355, 0370
DESIGNER: Nate Duval
CLIENT: Nate Duval

NODIVISION DESIGN SYNDICATE
J.P. Flexner
210 Victoria Drive
Montgomeryville, PA 18936
USA
410.251.4869
stop.nodivision@gmail.com

0031, 0501, 0799, 0800
DESIGNER: Robb Leef

OPM-OFICINA DE PROPAGANDA E MARKETING
Daniela Genuino
Av. Presidente Wilson, 228/10 andar
Rio de Janeiro, RJ 22230-170
Brazil
55.21.2544.1174
daniela@opm.com.br/fabio@opm.com.br
www.opm.com.br

0545, 0546, 0548, 0785
ART DIRECTOR: Fábio Marinho
DESIGNER: Daniela Genuino
CLIENT: Petrobras

ORANGESEED DESIGN

Kristin Murra
901 N. 3rd St., #305
Minneapolis, MN 55401
USA
612.252.9759 x205
kmurra@orangeseed.com
www.orangeseed.com

0383, 0384, 0385, 0386, 0387, 0388,
0389, 0390, 0391, 0549, 0550, 0551,
0552, 0553, 0554, 0555, 0556, 0557
ART DIRECTOR: Damian Wolf
DESIGNER: Kevin Hayes, John Wieland
CLIENT: Twin Cities Marathon, Inc.

ORANGEYOUGLAD

Tammy Duncan
423 Smith Street
Brooklyn, NY 11231
USA
718.219.0672
tammy@orangeyouglad.com
www.orangeyouglad.com

0177, 0959
DESIGNER: Tammy Duncan

PAPPAS MACDONNELL, INC.

Glenn Thode
135 Rennell Drive
Southport, CT 06890
USA
203.254.1944
gthode@pappasmacdonnel.com
www.pappamacdonnell.com

0341, 0950
ART DIRECTOR: Glenn Thode
DESIGNER: Greg Stewart
CLIENT: Pappas MacDonnell, Inc.

POPGUN CLOTHING

Patrick Sullivan
321 W. 7th St., #106
Kansas City, MO 64105
USA
816.547.9263
info@popgunclothing.com
www.popgunclothing.com

0278, 0704, 0954
DESIGNER: Patrick Sullivan, Chris
Evans
CLIENT: Popgun Clothing

POPIDIOT

Kelly Alder
3306 Gloucester Road
Richmond, VA 23227
USA
804.353.3113
Kalder@comcast.net
www.popidiot.com

0105, 0107, 0108, 0128, 0129, 0130,
0131, 0167, 0316, 0325, 0854
ART DIRECTOR: Kelly Alder, Jessica
Kantor
DESIGNER: Jessica Kantor, Kelly Alder
CLIENT: popidiot

PRINT BRIGADE

Chris Piascik
73 Fifth Street, Apartment 3
Cambridge, MA 02140
USA
203.815.9901
chrispiascik@gmail.com
www.printbrigade.com

0378, 0442, 0499, 0500, 0626, 0746, 0747
ART DIRECTOR: Chris Piascik
DESIGNER: Chris Piascik
CLIENT: Print Brigade

PROJECT M
25 Congress St.
Belfast, ME 04915
USA
207.338.0101
info@minesf.com
www.minesf.com

0538, 0915
CLIENT: The residents of Hale County, Alabama

PURSES BY PANTS
Heather J. Davis
2059 N. Avers Avenue
Chicago, IL 60647
USA
773.771.4182
davis@aadvert.com

0591, 0592, 0603, 0604, 0637

REBEL8
Joshy D.
1661 Tennessee St., #2L
San Francisco, CA 94107
USA
415.643.3933
www.REBEL8.com

0027, 0111, 0321, 0502
ART DIRECTOR: Mike Giant
DESIGNER: Joshy D.
CLIENT: REBEL8

RED PRAIRIE PRESS
Rachel Bone
3438 Ash Street
Baltimore, MD 21211
USA
443.622.1598
rachelbone@gmail.com
www.redprairiepress.com

0146, 0214, 0254, 0255, 0262, 0263, 0264, 0281, 0284, 0343, 0369, 0574, 0963, 0964
ART DIRECTOR: Rachel Bone
DESIGNER: Rachel Bone, Phil Davis
CLIENT: Red Praire Press

RYAN GOELLER
Ryan Goeller
9801 Stonelake Blvd., #336
Austin, TX 78759
USA
512.750.1593
me@ryangoeller.com
www.ryangoeller.com

0781
DESIGNER: Ryan Goeller
CLIENT: Beats Broke

S DESIGN INC.
Sarah Mason Sears
3120 W. Britton Rd., Suite S
Oklahoma City, OK 73120
USA
405.608.0556
sarah@sdesigninc.com
www.sdesigninc.com

0511
ART DIRECTOR: Sarah Mason Sears,
Cara Sanders Robb
DESIGNER: Jesse Davison
CLIENT: Schlegel Bicycle

SAYLES GRAPHIC DESIGN
Sheree Clark
3701 Beaver Ave.
Des Moines, IA 50310
USA
515.279.2922
sheree@saylesdesign.com
www.saylesdesign.com

0404, 0480, 0509, 0510
ART DIRECTOR: John Sayles
DESIGNER: John Sayles, Bridget
Drendel
CLIENT: East Village

**SCRAMBLED EGGZ
PRODUCTIONS**
Tom Watters
70 E. Main Street
Marlton, NJ 08053
USA
856.596.6990 x203
tom@scrambledeggz.com
www.scrambledeggz.com

0937
ART DIRECTOR: Tom Watters
DESIGNER: JP Flexner
CLIENT: Scrambled Eggz Productions

SHERIFF PEANUT
Norah Utley
1400 Elmwood
Berwyn, IL 60402
USA
773.263.2665
info@sheriffpeanut.com
www.sheriffpeanut.com

0082, 0086, 0767, 0769, 0770
ART DIRECTOR: Norah Utley
DESIGNER: Norah Utley

SIQUIS
Greg Bennett
1340 Smith Ave., Suite 300
Baltimore, MD 21209
USA
410.323.4800 x127
greg@siquis.com
www.siquis.com

0949
ART DIRECTOR: Greg Bennett
DESIGNER: Greg Bennett
CLIENT: Rehoboth Beach Film Society

SOPHOMORE
Christiane Miller
195 Chrystie St.
New York, NY 10002
USA
212.477.7570
chrissie@sophomorenyc.com
www.sophomorenyc.com

0589, 0590, 0618, 0849, 0991

SPAGHETTI KISS
Michael S. Bracco
3022 Glenmore Ave.
Baltimore, MD 21214
USA
443.562.3327
girlyboy17@hotmail.com
www.spaghettikids.com

0096, 0100, 0222
DESIGNER: Michael S. Bracco

SQUIDFIRE
Kevin Sherry
4401 Eastern Ave.
Baltimore, MD 21224
USA
410.327.3300
jbr@squidfire.com
www.squidfire.com

0085, 0117, 0118, 0184, 0191, 0192,
0201, 0202, 0312, 0313, 0314, 0363,
0368, 0776, 0955, 0978
ART DIRECTOR: Jean-Baptiste Regnard
DESIGNER: Kevin Sherry
CLIENT: Squidfire

STUDIO INTERNATIONAL
Boris Ljubicic
Buconjiceva 43
Zagreb, HR-10000
Croatia
+385.137.40404
boris@studio-international.com
www.studio-international.com

0443, 0641, 0642, 0644, 0732, 0733,
0812, 0953, 0994
ART DIRECTOR: Boris Ljubicic
DESIGNER: Boris Ljubicic
CLIENT: VARTEKS

SUKSEED
Jason Yun
13151 Fountain Park Dr., 6306
Playa Vista, CA 90094
USA
626.833.2087
jyunbreakdown@yahoo.com
www.jasonyun.com

0071
ART DIRECTOR: Jaosn Yun
DESIGNER: Jason Yun
CLIENT: Paradigm Industries

**THE FADED LINE
CLOTHING CO.**
Brad Mastrine
1094 Hawk Ct.
Louisville, CO 80027
USA
303.544.5804
mastrine@thefadedline.com
www.thefadedline.com

0033, 0070, 0103, 0156, 0157, 0172,
0173, 0198, 0209, 0848, 0995, 0996
ART DIRECTOR: Brad Mastrine
DESIGNER: Emer, Todd Slater, Jim
Pollock, Jeff Wood

THREADLESS
Jeffrey Kalmikoff
4043 N. Ravenswood, #106
Chicago, IL 60613
USA
773.878.3557
jeffrey@skinnycorp.com
www.threadless.com

0006, 0019, 0020, 0036, 0037, 0046,
0055, 0057, 0059, 0061, 0072, 0087,
0097, 0098, 0109, 0110, 0124, 0127,
0144, 0145, 0155, 0161, 0168, 0169,
0174, 0175, 0176, 0185, 0186, 0195,
0220, 0221, 0224, 0228, 0229, 0249,
0257, 0267, 0282, 0286, 0287, 0288,
0289, 0290, 0299, 0300, 0303, 0304,
0305, 0306, 0309, 0319, 0329, 0330,
0334, 0347, 0350, 0351, 0356, 0362,
0372, 0374, 0375, 0377, 0450, 0452,
0453, 0454, 0455, 0456, 0457, 0516,
0572, 0578, 0621, 0622, 0624, 0625,
0627, 0628, 0629, 0630, 0631, 0632,
0669, 0672, 0673, 0674, 0675, 0677,
0678, 0679, 0680, 0707, 0708, 0709,
0710, 0711, 0712, 0713, 0714, 0716,
0745, 0751, 0752, 0768, 0778, 0798,
0801, 0802, 0828, 0844, 0846, 0847,
0860, 0861, 0862, 0863, 0878, 0892,
0902, 0909, 0910, 0912, 0934, 0961,
0962, 0975, 0976, 0980, 0982, 0984,
0985, 0986, 0987
DESIGNER: Threadless

TOKIDOKI LLC.
Simone Legno
5645 West Adams Blvd.
Los Angeles, CA 90016
USA
323.930.0555
simone@tokidoki.it
www.tokidoki.it

0981
ART DIRECTOR: Simone Legno
DESIGNER: Simone Legno
CLIENT: tokidoki

TRADER JOE'S
Jessica Frease
117 Kendrick St., Suite 700
Needham, MA 02494
USA
781.455.7316
jfrease@traderjoes.com
www.traderjoes.com

0921, 0922
ART DIRECTOR: Jack Killeen
DESIGNER: Jessica Frease
CLIENT: Trader Joe's

T-SHIRT INTERNATIONAL, INC.
Greg Forsythe
3611 Bakerstown Rd., Suite 3
Bakerstown, PA 15007
USA
724.443.2717 x103
gregf@tsisportswear.com
www.tsisportswear.com

0358
ART DIRECTOR: Greg Forsythe
DESIGNER: Greg Forsythe
CLIENT: Lost Creek Outfitters

WILLIAM HOMAN DESIGN
William Homan
111 Marquette Ave., Suite 1411
Minneapolis, MN 55401
USA
612.869.9105
william@williamhomandesign.com
www.williamhomandesign.com

0580, 0581, 1000
ART DIRECTOR: William Homan
DESIGNER: William Homan
CLIENT: Galloup's Slide Inn

WILLOUGHBY DESIGN GROUP
Ryan Jones
602 Westport Rd.
Kansas City, MO 64111
USA
816.561.4189
rjones@willoughbydesign.com
www.willoughbydesign.com

0948, 0999
ART DIRECTOR: Ann Willoughby, Zack Shubkagel, Anne Simmons, Megan Semrick
DESIGNER: Jessica McEntire, Stephanie Lee, Nate Hardin
CLIENT: Willoughby Design Group

WING CHAN DESIGN, INC.
Wing Chan
167 Perry Street, Suite 5C
New York, NY 10014
USA
212.727.9109
wing@wingchandesign.com
www.wingchandesign.com

0519, 0528, 0575, 0577, 0583, 0923, 0924, 0925, 0926, 0927, 0928, 0929, 0930, 0931, 0932
ART DIRECTOR: Wing Chan
DESIGNER: Wing Chan
CLIENT: Songs for Children Charity

XEROPROJECT
Jamie Kashetta
513 Mirasol Circle, #203
Celebration, FL 34747
USA
407.566.8164
jamie@xeroproject.com
www.xeroproject.com

0034, 0774, 0789, 0818
ART DIRECTOR: Jamie Kashetta
DESIGNER: Jamie Kashetta
CLIENT: xeroproject

0116, 0119, 0820, 0821
ART DIRECTOR: Jamie Kashetta
DESIGNER: Jamie Kashetta
CLIENT: niki bar band

0541, 0771
ART DIRECTOR: Jamie Kashetta
DESIGNER: Jamie Kashetta
CLIENT: light the sky

ABOUT THE AUTHOR
ACKNOWLEDGEMENTS

Jeffrey Everett started El Jefe Design in 2003 while receiving his MFA in graphic design from the School of Visual Arts in New York City where, conveniently, his thesis project was starting a T-shirt company. Now located outside of Washington, D.C., El Jefe Design has had the pleasure of designing and illustrating for a wide variety of entertainment and non-profit clients. The studio is known for creating award-winning posters for nationally touring music acts big and small. El Jefe Design has had work shown in magazines such as *Print, How,* and *STEP Inside Design* and won awards from the AIGA and The Art Directors Club. For more information, visit **www.eljefedesign.com.**

The author would like to thank the following people for their invaluable help in creating this book: Steven Heller, Anya Kholodnov, Jeffrey Wright, the hard workers at Rockport Publishers; my family and friends for supporting me through the long nights; and Maximilian for making it all mean something.